The news aesthetic

# THE NEWS AESTHETIC

The Herb Lubalin
Study Center of
Design and Typography

The Cooper Union
School of Art
New York City
12 April – 12 May 1995

# THE COOPER UNION

Published by
The Herb Lubalin Study Center of
Design and Typography
The Cooper Union School of Art
7 East 7th Street
New York NY 10003
212 353-4214

Robert Rindler, Dean
School of Art

Georgette Ballance
Acting Director

Lawrence Mirsky
Assistant Director

Distributed by
Princeton Architectural Press,
A Kiosk Book
37 East 7th Street
New York NY 10003
212 995-9620

ISBN # 1-56898-051-5

# CONTENTS

# Colored Lenses

"The Wonderful World
of Color News"

# THE RISE OF COLOR IN THE MEDIA

## The Yellow Journal Spectre Still Haunts Modern Newspapers

### By MICHAEL ROCK and PAMELA HOVLAND

The color newspaper has come under unusual scrutiny in the past decade. The debate over colorized news has been fueled in large part by the advent and subsequent growth of *USA Today* and a slew of local papers that have imitated the national daily's bright facade. However, while recent journalistic critiques posit colorization as a contemporary phenomcna – the inevitable consequence of a culture bathed in video rays – color newsprint has a long and complex history, and much of it only sketchily documented or apocryphal. Color itself has a tangled history in twentieth-century America; its elusive properties have been evoked in connection with topics that touch almost every corner of the cultural landscape, from the aesthetic to the politics of race.

The discourse surrounding the rise of color in the media is impossibly broad. Therefore this discussion will focus on the efficacy of color reproduction and the way in which its use has been linked to the emerging news media over the course of the last century. While concentrating specifically on newspapers and news magazines, we will examine how advances in other media shaped both the production and consumption of colored information. Furthermore, we will consider some prevailing notions about color; for example, color as a detriment to public taste, its impact on consumer choice, the sub-rational appeal of color, and color as a feminized marketing device. In conclusion, we will suggest ways in which the meaning of color has shifted and assumed new political significance.

Color first infiltrated the black and white world of the newspaper almost exactly one hundred years ago, and much of the current rhetoric that swirls around the topic is directly related to its late nineteenth century origins. Spot color appeared on mastheads and special editions as early as 1891; the *Milwaukee Journal*, an early color pioneer, ran a red, white, and blue banner to announce the gubernatorial inauguration on January 5th of that year. The *New York Recorder* employed color in its editorial pages by 1893, the *New York Herald* in 1894, and the *New York Journal* and *Chicago Tribune* followed suit in 1897.[1] While the technology existed to include color on all pages – chromolithography was well established and was used to churn out reams of cheap color printed matter for every variety of consumer product and package – time was the real obstacle. The inclusion of an extra color (aside from black) was labor intensive and the practice was practically impossible within traditional newspaper deadline structures. Color was therefore used sparingly, to announce a holiday or special event, its very presence a sign of consequence.

The real color invasion took place in the form of the Sunday supplement. After buying the floundering *New York World* from Jay Gould in 1883, the legendary publisher Joseph Pulitzer built it into the most successful paper in America, employing the techniques now associated with what is derisively labeled "tabloid journalism." By the early 1890s, in a scheme to democratize high culture, Pulitzer had developed a system for the creation of full color, fine art reproductions of famous renaissance paintings for inclusion in the paper and subsequent distribution to the masses. While the elevation of mass taste was a popular cause for many of his fellow philanthropists and captains of industry, Pulitzer's motivation was probably as much competition

*Continued From Page 7*

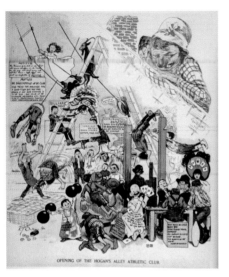

Hogan's Alley, 1896

from the rival *New York Journal* as it was public edification. The *other* legendary newspaperman of the era, William Randolph Hearst, had purchased the *Journal* in 1894 and was challenging the *World*'s ascendancy. Technological innovation was one of the many fronts on which the battle between the two papers was waged.

Ironically, while the fine art reproduction project failed – newsprint was simply too coarse to hold fine detail – the process Pulitzer put into place did promote a certain, albeit more common, artform: the colored comic papers. The *World* publisher introduced one of the first color comic supplements in a Sunday edition in 1894, and Hearst quickly countered with an expanded color supplement in the *Journal* the following year. The ensuing circulation war is legend, and the brand of inflammatory reportage practiced by the two papers and their many imitators has been aptly labeled "yellow journalism." The term is derived from the Yellow Kid (aka Mickey Dugan), a character in Richard Felton Outcault's comic tableau, *Hogan's Alley,* that ran in the *World* until Hearst lured the artist to the *Journal.*[2] That a comic-strip character would become the eponym for a form of muckraking is telling, for the Sunday "fun-

## *"It does not soil the breakfast cloth"*

ny papers" became an emblem of the unabashed appeal this new brand of sensational journalism had for the masses. The brightly colored papers were derided by respectable journalists of the day; as one historian has suggested, "[c]omics seemed to the elite the obviously lowbrow Pied Piper which lured the innocents to their journalistic doom."[3]

The period of yellow journalism lasted into the first decade of the twentieth century and continues to have a profound effect and influence on our contemporary image of responsible news coverage. The representative features – scare headlines in gigantic type, lavish illustration and photography, pseudo-scientific articles, color comic strips, jingoistic crusades for popular causes[4] – are almost identical to the qualities frequently disdained in the contemporary tabloid press, both print and video. When Adolph Ochs assumed

control of the *New York Times* in 1896, he eschewed the muckraking of the *World* and the *Journal*, insisting the *Times* would run "all the news that's *fit* to print" [my italics]. But his first slogan, now forgotten, is more revealing: "It does not soil the breakfast cloth," a reference to the tendency of the color supplements to smudge.[5] The conflation of tabloid color and "dirty" practice was clearly implied.

As colored products and materials spilled increasingly from print shops and manufactories of the industrial revolution, so too was there a rise in academic and popular studies of the persuasive and mysterious properties of color. A number of texts attempted to quantify the exertive force or power of color, postulating a sub-conscious response to color that could be harnessed for the good of mankind, increased sales, or enhanced beauty. Thus by the 1890s books began to appear with titles like these: *The Theory of Color in its Relation to Art and Industry,*[6] *The Mysticism of Colour,*[7] *On colour, and on the necessity for a general diffusion of taste among all classes,*[8] *The laws of harmonious colouring,*[9] *The Principles of Beauty in Coloring Systematized.*[10]

One popular theme shared by a number of such texts was the classification of color in terms of "primitive" response. *The Colour-Sense; its Origin and Development* by Grant Allen, published in 1892, is typical. Allen rated color on a scale of sophistication, with red and orange on the bottom, stirring a long forgotten "savage love for torchlight dances, for bonfires, and for like rude pyrotechnic displays." Color was postulated as a primal force, appealing to the coarsest desires. "In every case we feel at once that the aesthetic pleasure involved [with bright colors] belongs to the very lowest stratum of its class, the stratum which we Europeans share in the greatest degree with the savage members of our race. Children and uncultured adults delight in the rude shocks of a fire-work exhibition, but the sensitive eyes and minds shrink from the excessive demand upon the optic nerve and brain."[11]

The association of bright color with primitive urges led some turn-of-the-century writers to express concern for the maintenance of public taste in an environment increasingly tainted by chromolithography and color newspaper supplements. Numerous reform movements and arts and crafts guilds, loosely modeled on William Morris's Kelmscott Press, promoted a return to handcraft and promised to restore sobriety to publishing. (The Bauhaus pedagogy with its emphasis on a mystical attachment to the primary colors and simplified forms is a later development of this same reform movement.) Still, academic con-

cern for the dangers of color printing and manufacturing had little effect on its speedy proliferation.

Unlike the introduction of color television, however, which effected a quick and total color conversion in the media, color came to printing in fits and starts and has continued to exist comfortably with black and white reproduction up to the present day. "The reception of color within printing media, then, reflected a culture with established iconographic traditions," Neil Harris has noted, "which accepted a variety of rendering techniques; was prepared to accept slow, indefinite progress as a condition; and demanded neither uniformity of technical quality nor pervasiveness of penetration."[12] Furthermore, despite the growing popularity of color in magazines, it remained a rarity in the body of the newspaper, continuing primarily as a supplement or as spot color for advertisements. The division between color (an added attraction with marketing or entertainment appeal) and black and white (reserved for journalism and *hard* news) stood unchallenged until the late 1970s.

---

With the development of synthetic materials – Bakelite and linoleum, for instance – and new manufacturing processes, researchers were working to bring color to all manner of consumer goods by the early decades of this century. Louis Weinberg, author of *Color in Everyday Life* (1918), encouraged businessmen to study the promotional potential of color: "In the field of business...there are few lines in which a knowledge of color is not essential. The businessman uses color and pays dearly for its use."[13] In 1927 Ford followed General Motors in producing their new *Model A* in several colors, besides the standard black used for the *Model T*, from which consumers could choose. As products diversified and the ideology of consumer choice came to the forefront, color was one of the key choices available.

That choice of color was increasingly linked with loose consumption and impulsive behavior. For example, Roland Marchand recounts AT&T's debate over the replacement of standard black telephones with colored models as a method for promoting the telephone for "frivolous conversation."[14] (The company resisted the pressure – as some company executives apparently considered color a sign of "depravity,"[15] – until the late fifties, by which time promoters were promising "color will be the banner under which the American public may indulge itself in one of its chief fancies— the free and delightful choice of wanted things."[16])

By the twenties a number of systems for making color film, or tinting black and white film, were under development. Between 1912 and 1921, two scientists from MIT, Herbert T. Kalmus and Daniel Comstock, perfected an early process they patented as "Technicolor." In 1921, the first Technicolor movie was released, *Toll of the Sea.* Early Technicolor was both expensive to produce – up to three times more than black and white film – and of rather poor quality.[17] Color was often seen as a distraction in films, interrupting the smooth flow of the narrative. The poor quality and unskilled use of color led to its reputation as an expensive gimmick, a last ditch effort to save a fatally flawed film that could not succeed on its own merits.[18]

A new Technicolor process released in the early thirties significantly improved the quality of color filmmaking. After the release of *Becky Sharp,* the first film shot in a new 3-color Technicolor process, the use of color became a viable dramatic device rather than a novelty. The debate shifted to the efficacy of color. In a *Newsweek* article on the release of *Becky Sharp,* the author observed an emotional power from the use of the color: "[The directors] used color psychology deliberately to heighten the story. For quiet scenes they stressed soft somber hues. But to emphasize the excitement...they deepened the color mood."[19] In many of the same ways that it was analyzed in product and advertising design, color film was imagined as an emotional device that could be utilized to manipulate the reaction of an audience.

By the end of the 1920s, specially colored products were available for every room in the home. In an environment in which color was both the consumer's desire and a marketing device employed to differentiate products, manufacturers had to reimagine their wares. No longer relegated to the category of utilitarian objects, telephones and automobiles, in color, became objects of fashion and "sex appeal."[20] The appeal of color as a persuasive device, as demonstrated in the power of color film, was not lost on the advertising industry. It meshed perfectly with their constant search for new ways

The Yellow Kid, aka Mickey Dugan, 1896

*Continued on Page 10*

*Continued From Page 9*

to sell consumer products and their quest for new quasi-scientific sales techniques by means of which to impress and lure clients. Advertisers increasingly demanded the option of color in their ads, and the new magazines such as *Time*, *Life* and *Newsweek* were there to fill that demand. The placement of color advertisements in the news magazines opened up the possibility of mass produced color images used in conjunction with the news. Both *Time* and *Life* employed color as a major identifying feature; *Time*'s signature was, and is, a red border and *Life*'s a bright red masthead from their inception (although *Time* experimented with orange and green for a brief period in the late twenties). *Newsweek*, founded six years after *Time*, ran its first color news photo, a candid portrait of Franklin D. Roosevelt, on November 2, 1935, and after the interruption of the war, began running occasional color spreads as early as 1946.[21]

Even though the technology was available and the weekly schedule somewhat more forgiving than that of the daily newspaper, news magazines, for the most part, maintained the strict separation between the black and white *hard* news and the more colorful spheres of entertainment, travel and leisure, and advertising. A quick survey of the early color spreads in *Newsweek* reveals an emphasis on soft news: 1953, Italian Movie Stars, Japanese Opera; 1956, National Parks, Folk Art, Oakhill Golf Course; 1957, Life and Leisure in Amsterdam.[22] In an article entitled "Colour Photography in Journalism" in a printer's journal, the *Penrose Annual* of 1955, Michael Middleton suggests that color and black and white images are suitable for different kinds of stories. "It is not often that a news event will lose its impact if seen only in black and white; more frequently the [color] picture-journalist chooses a seasonal subject for use in its appropriate period, which he knows will have colour, glitter, and excitement."[23]

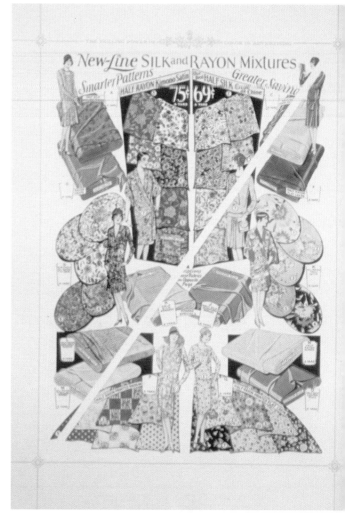

Middleton goes on to limn the distinctions between the two techniques and to remark upon a rising concern, namely competition among media:

[I]t is perhaps idle to speak of "*colour* photography in journalism"; there is practically none now; there seems likely to be even less in the near future, for the time-lag in production which makes it difficult for the mass-circulation weeklies to compete with television and the cinema even in black and white, becomes a well-nigh insuperable barrier in the case of colour. In any event no colour story, to my way of thinking, has yet been shot to compare with the more memorable black and white essays that come easily to mind from the past fifteen years like those of Robert Capa in Spain, Ernst Haas' returning POWs in Germany, Eugene Smith's essay on Chaplin, Bert Hardy in Korea.[24]

Middleton contended that the color image did not have the compositional strength to evoke a story, but instead worked to trigger emotion or mood but not intellectual thought.

In the same issue of *Penrose*, C. Maxwell Tregurtha revisits the divided issue of color in print:

There are arguments for and against color in print. Take that marvelous production the *Saturday Evening Post*. Look through its pages. The first few openings are in black and white, clean, trim, attractive. Then you hit on "Campbell's Soup" page. This is a rhapsody in red. It stands out by sheer force of colour and design. "Wonderful" you say as you look at it. Then you turn over and the Campbell impression is blotted out by the superb realistic art and colorfulness of, say, "Libby's Milk" page. The editorial page facing it looks drab by contrast. Turn over more pages and the continuous panorama of colour gradually blinds your colour-perception until you welcome a return to black on white. It looks so clean and interesting and business-like.[25]

*The Pulling Power of Color in Advertising,* 1930

Tregurtha implies that the clear division between color and black and white symbolized the fiercely defended cleft between the editorial and the advertising/circulation departments, known humorously as the "division of church and state." Because color was used exclusively in the advertising pages and seemed to appeal to the irrational and emotional rather than to the intellectual side of the reader's nature, the encroachment of color into the news columns smacked of a marketing ploy that journalists feared would sully the hard won objectivity of "the Fourth Estate."[26]

Tregurtha ends his article with the question "Shall we one day have colour in our

newspapers?" He answers in the negative and continues: "[P]robably we should be thankful for that for then there would be no escape from the tyranny of colour except by refusing to read a newspaper at all."[27] Clearly, however, the author was not well acquainted with American newspapers. By the time he asked his rhetorical question, over 580 newspapers in the United States were offering run-of-paper color[28] – usually spot but occasionally four color process – to their local and national advertising clients who purchased close to 50 million lines of color space (1.6% of all display ad space for the year).[29] In countless ads in trade magazines and advertising journals, newspaper advertising departments promised big results from a color campaign.

The infusion of color theory into the "science" of marketing that started in the mid-twenties was in full swing by the late fifties. The cautionary language and reformist zeal of the first decades of the century had given way to a more optimistic approach, i.e. color sells. Perhaps the most ardent promoter of color as a sales tool was Faber Birren, a self-styled color expert who wrote over forty books on the subject (including prescient volumes on the appropriate colors of clothing and make-up for women that anticipated the *Color Me Beautiful* fad of the 1980s). In 1956 Birren announced, "The nation is no longer merely color-conscious; it has become almost completely color-minded." Later he expounded, "Psychologically, the world wants color. Where it is lacking, the dimensions of beauty and appeal are sadly incomplete."[30]

Birren had a tendency to wax prosaic in his utopian, full-color dreams: "Maybe this orgy of color has become something of an emotional spree on the part of the public, but mostly it has ful-filled human desire and has made of color one of the major wants and pleasures of modern times." However, when dealing with the advantages of color to the business man, Birren did not mince his words: "The beautiful colors are the ones that sell; the ugly colors are the ones that don't." In his 1956 volume *Selling Color to People*, Birren theorized color as a motivational force that could be harnessed to first attract consumers and then encourage them to continue to purchase new products:

In business, color has economic importance. The right use of it is a stim-ulus to better sales and greater volume. It is one of the chief wants of the American public, having become part and parcel of the American standard of living and the American way of life. Properly used, color will provide untold pleasure to the masses of population—while keeping the machinery of production and distribution humming.[31]

If there was any question about the nature of Birren's ideal con-sumer, the feminine pronoun of the following passage makes it clear. "She will, perhaps, look at the price first, examine quality second, and then grant third place to emotional feeling. Howev-er, let this emotional feeling be compelling enough, and she will fling open her purse with almost reckless abandon."[32] Accord-ing to Birren, color was such an effective marketing device pre-cisely because it was able to detonate the impulsive emotional reactions so closely tied to the putative notion of the female consumer. Writing on the advent of color television advertising, Birren is even more direct: "Color may spark the eternal desire of women to shop and spend money."[33]

The introduction of color into new arenas was consistently accompanied by a parallel discourse of innovation and novelty. Thus newly introduced color can render the existing technology or the surrounding monochromatic space anachronistic. Within the sphere of color itself, new tints and shades constantly replace "last year's colors" in the voracious cycle of consumerism, and color becomes a factor in the planned obsolescence of goods. For the first time, a washer or a telephone could become out-dated not because of mechanical failure but because its appearance was no longer fashionable. Color was almost always introduced as "the newest feature," then quickly accepted as the norm. The advent of color film-making, for instance, rendered black and white meaningful. Black and white was consciously *not* color, thus intentionally serious, old-fashioned, or low budget.

By the same token, the distinctive look of a new or innovative technology can, over time, come to symbolize the outmoded. Color film was first trumpeted as approximat-ing the real world; cinema set designer Robert Edmond Jones proposed that "color should be no more prominent than it is in everyday life."[34] As reproduction tech-

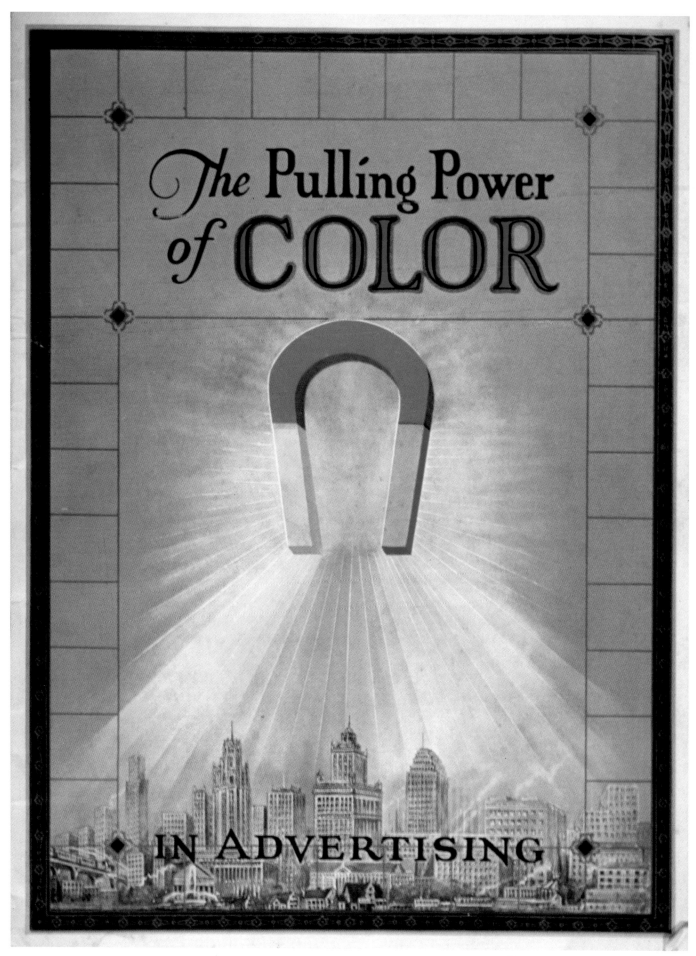

The Pulling Power of COLOR

IN ADVERTISING

Early examples of color as a selling point.

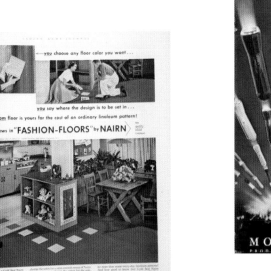

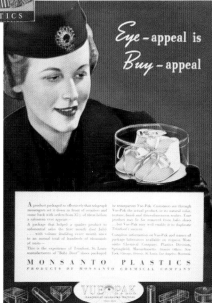

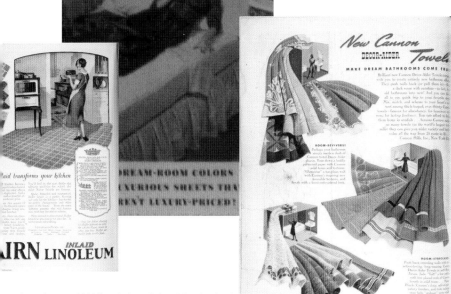

*Continued From Page 11*

niques improved and color film became the expected norm, the bright, somewhat unrealistic color associated with the Technicolor process came to signify the plastic, saccharine world of popular fifties cinema. Black and white films came to represent a gritty reality in contrast to the glitzy, colorful Hollywood spectacle. Therefore, the disdainful label, "Technicolor Tabloid," applied to *USA Today*, splices the tabloid's shameless appeal to mass sentiment with the lingering notion of Technicolor as the empty embellishment of a flawed film.

The same transformation was visible in the use of color photography in news reportage. In an article celebrating monochromatic photography "The Lasting Power of Black-and-White," author Eric de Maré once again evoked the primordial allure of color: "Colour photography is, of course, a most valuable advance, as in teaching, for instance, in fashion illustration, and in many other ways, and one must admit that colour is seductive in itself and gives a primitive delight which is as old as humanity." Yet, as seductive as it may be, "colour tends to weaken, rather than enhance, the visual impact of the photographic image. If that is not so, why do memorable photographs

# "The beautiful colors are the ones that sell;

# the ugly colors are the ones that don't."

## Faber Birren

**NEW STUDY REVEALS...**

**"Color may spark the eternal desire of women to shop and spend money."**

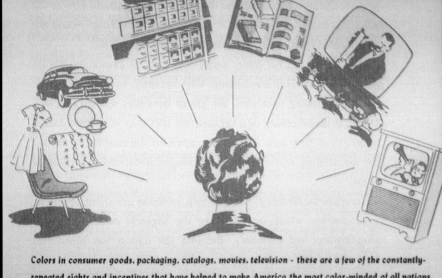

Colors in consumer goods, packaging, catalogs, movies, television - these are a few of the constantly-repeated sights and incentives that have helped to make America the most color-minded of all nations.

in black and white so overwhelmingly outnumber those in colour?" [35]

The advent of color television had a powerful effect not only within the medium but on the surrounding media as well. While the introduction of color was rather slow in film and peripatetic in printing, the colorization of television was swift and complete. The technology for producing color television was developed in the forties, but the network and apparatus were not in place for color broadcast until the early sixties. Once available, however, color television's ascension was meteoric. Between 1963 and 1969 the number of homes with at least one color television jumped from 3% to 33%.[36] CBS announced in their 1965 annual report that a full 50% of their schedule had been broadcast in color during the previous year, and by the following fall the entire evening line-up would be in full-color.[37] In 1961, the Walt Disney company switched their Disneyland program on ABC to NBC in order to take advantage of that network's color broadcasting capabilities and introduced a new name: Walt Disney's Wonderful World of Color.

Color was aggressively marketed by both network executives and advertisers, who were eager to sell the new medium to clients. A print ad promoting color TV crowed, "Color programs rate double the popularity of the same program in black and white...and color TV commercials rate 3 1/2 times the impression as the same commercials in black and white."[38] By the early seventies all new television programming was in color. Advertisers were reluctant to sponsor black and white programming as its antiquated quality reflected negatively on their product, and at the same time, they were averse to running a black and white ad with

confined to society events and travel pictures began to engage serious subjects: 1964, both political conventions featured in color; 1965, extensive coverage of the Vietnam war; 1968, the Tet offensive, Martin Luther King's funeral, the summer riots, the Biafran/Nigerian war. For a spe-

# She will fling open her purse with almost reckless abandon

cial issue published on January 3, 1977, the editors announced: "This week, the whole panorama of 1976 is captured in an issue-length portfolio of the year's most evocative images, among them an unprecedented 27 pages of color photographs."[41] (This unprecedented event did not apparently meet with universal approbation. In the following issue a reader complained, "Whether or not a picture is really 'worth a thousand words' it certainly is cheaper and easier to produce. You can't compete with television's mastery of glossing over events."[42])

a color program for fear of looking out of date.[39] "Color in television offers exciting possibilities," Faber Birren noted, "not only in the field of entertainment but in the sale of consumer goods. It is sure to accomplish (over black and white) equal if not more success than has been attained in magazines, catalogs and direct mail."[40]

With the colorization of television news and their own marketing studies indicating the loss of younger audiences to television, news magazines began seriously to reconsider their avoidance of color imagery in the editorial section. While news magazines had once evoked the "grey respectability" of the important newspapers, they were suddenly competing head to head with a new medium that was transmitting hard news in full color everyday. By the mid-sixties, *Newsweek*'s color spreads that had been

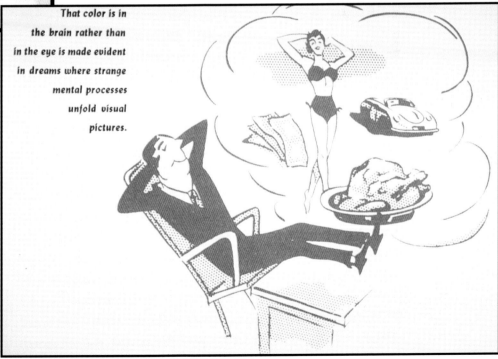

That color is in the brain rather than in the eye is made evident in dreams where strange mental processes unfold visual pictures.

*Selling Color to People*, 1945

VIA SATELLITE     THE NATION'S NEWSPAPER     50 CENTS

INSIDE SPORTS

## BIGGEST QUESTION IN NHL: WHEN?

FANS ARE CALLING ABOUT SEASON-TICKET SALES, 1C
▶ Opening night plans, 8C

TREVINO: Pain went away immediately, 3C

## TREVINO TRIES OUT TITANIUM — BUT NOT IN HIS CLUBS

METAL PLATE IN NECK HELPS GET HIM BACK ON TOUR, 3C
▶ Weekend golf, 1,3,3C

# USA TODAY

NO. 1 IN THE USA . . . FIRST IN DAILY READERS

WEEKEND EDITION

## CAT IN HAT ENLISTED TO BATTLE MICKEY 1D

UNIVERSAL PLANS DR. SEUSS PARK NEAR DISNEY WORLD

## VJ DAISY FUENTES' CAREER ROCKS EVEN WHEN SHE'S OFF MTV

MULTI-FACETED 'BABE WITH A BRAIN' IS GOING PLACES, 1D

FUENTES: 'Comfortable with MTV, 1D

---

AFC

SAN DIEGO at PITTSBURGH
SUNDAY 12:30 p.m. ET, NBC

Stan Humphries ▶
Rod Woodson ▶

# SUPER SCRAMBLE

▶ Super Bowl berths at stake, 1,6,7C
▶ Advertisers cheer NFC bargain, 1B

NFC

DALLAS at SAN FRANCISCO
SUNDAY 4 p.m. ET, Fox

Steve Young ▶
Emmitt Smith ▶

---

FRI./SAT./SUN., JANUARY 13-15, 1995

# NEWSLINE

A QUICK READ ON THE NEWS

**WALL STREET:** Dow Jones industrial average slips 3.65 points to 3858.00. Nasdaq index inches up to 750.51. 30-year Treasury bond yield rises to 7.97%. 1,3B

**SIMPSON CASE:** Trial of O.J. Simpson pushed back one day; prosecutors dropping 19 allegations. 3A

**CAR TALKS:** Walter Mondale, ambassador to Japan, left, and trade representative Mickey Cantor meet in Detroit with honchos of Big Three automakers to hone up for talks aimed at opening Japan's markets. 4B

MONDALE: Dignity and strength

**RUSSIA CONFLICT:** Russian warplanes continue assault on Chechen capital of Grozny, despite Chechen President Dzhokhar Dudayev's call for peace talks. 6A

**WOLVES' RELEASE:** Federal appeals court paves way for release of Canadian gray wolves into U.S. wilds. 3D

**CANADIAN SLUMP:** The fall of Canada's dollar threatens to worsen USA's persistent trade gap. 1B
▶ Mexico's ailing stock market and peso rally again. 1B

**LUXURY-UTILITY:** Lincoln will add upscale sport utility based on Ford Bronco. Target date is early 1997. 1B

**TODAY'S DEBATE:** Prior behavior as evidence. IN USA TODAY's opinion, Simpson case shows "why past events shouldn't automatically be admissible in court." 8A
▶ "Juries in criminal cases should routinely hear evidence of a defendant's prior acts," says Bruce Fein. 8A

**MONEY:** Continental cutting back on Lite service. 1B
▶ Sportswear maker Fila runs after bigger sales share. 3B

**SPORTS:** Aussie Open even face tough going. 1,8C
▶ UMass, Tennessee stay atop men's, women's hoops. 1,2C

**LIFE:** Disney pitches forthcoming film at malls. 1D
▶ ★★★½ True Lies and ★★★ White. Movies on video. 3D
▶ Saxophonist James Carter is jazz's rising star. 4D

### COMING MONDAY

**THINKING SMALL:** Top stock picks from five expert small-company stock pickers, and tips on buying into the volatile little stocks.

By John D. Buckley

Inside USA TODAY 4 SECTIONS

| | |
|---|---|
| Classified | 6-7D |
| Crossword | 8D |
| Editorial/Opinion | 8-9A |
| Lotteries | 3C |
| State-by-state | 8A |
| Stocks | 4,8-9B |

© COPYRIGHT 1995 USA TODAY, a division of Gannett Co., Inc.

## USA SNAPSHOTS®
A look at statistics that shape the nation

### How health care bills are paid

Source: Health Care Financing Administration, 1993 figures.
By Cindy Hall and Julie Stacey, USA TODAY

---

# Calif. looks for rain relief

## WHO CONTROLS KING LEGACY?

HEIR: Dexter Scott King, Coretta Scott King have ousted park service from family land

### Competing plans for historic site

The National Park Service wants to upgrade its visitor facilities. The King family wants the land for an educational center. The King Center stopped park service tours last month.

KING JR.: Killed in '68

**Park Service plan**
A proposed new site for Ebenezer Baptist Church and visitors center.

King Center plan

ATLANTA

---

### Plea bargain urged for mom who killed tots

By Robert Davis
USA TODAY

The South Carolina sheriff who cracked the Susan Smith murder case is calling for a plea bargain to avoid a possible death sentence.

"What may be best . . . is to go beyond this and negotiate a plea bargain," says Sheriff Howard Wells, noting the small town has "been through a lot."

Prosecutor Tommy Pope says he weighed the wisdom of Wells, the Smith family and many others when deciding whether to seek the death penalty. He'll reveal his decision Monday before a Union judge.

Smith, 23, last year shocked the USA by claiming sons Michael, 3, and Alex, 14 months, were abducted by a black carjacker. She later admitted drowning them in her car.

Her lawyer, David Bruck, says the state has not made an offer for a plea bargain.

"People here want this behind them," says Max Johnston of the Union Chamber of Commerce. "Certainly, remember those children's lives and learn from the tragedy, but let's move on."

He says having "the girl next door" face the death penalty may take the biggest toll.

### COVER STORY

# Civil rights circles split over conflict

King "belongs to society. . . . He's too much of a public property"

By Ben Brown and Patricia Edmonds
USA TODAY

ATLANTA — As the nation prepares to celebrate Sunday's 66th anniversary of Dr. Martin Luther King Jr.'s birth, the slain civil rights leader's family is locked in a bitter battle over control of his legacy.

The immediate dispute surrounds competing plans for rehabilitating part of Atlanta's historic King District. Who should control it — the National Park Service or King's family? What should they build — an $11.8 million government-run visitors center, or a $60 million, family-run theme park our critic dubbed "I Have a Dreamland"?

Beyond this angry clash of blueprints lays deeper questions. Who may hold title to "the dream"? Can anyone — should anyone — nation or profit from King teachings that, in 30 years, have enriched and transformed the globe?

This longer issue has split civil rights circles, leaving one-time King intimates on opposing sides of the debate.

On one side: Critics including activist Hosea Williams and U.S. Rep. John Lewis, who say King's legacy shouldn't be dispensed like a commodity, "up for sale like soap."

On the other: Former Atlanta mayor Andrew Young, Southern Christian Leadership Conference head the Rev. Joseph Lowery, and others who say family, not government, has the right to control King's "intellectual property."

Please see COVER STORY next page ▶

---

GUERNEVILLE, Calif. — California can expect to get a break from flooding once today's rain ends.

That will give residents time to ponder the bad news earthquake researchers offer in the journal Science this week.

Creeks and rivers were receding in southern California Thursday while officials began adding up the damage in the northern part of the state.

Today's heavy rains will range from the San Francisco Bay area and Sacramento across northern California, Oregon and Washington.

Southern California should be dry today, says Michael Henry, Weather Services Corp.

"It looks encouraging for the first time in quite a while," Henry says. "We don't see storms lined up in the Pacific ready to come in."

California won't be alone today in grappling with weather-related problems.

Air travelers can expect morning delays today from the Great Lakes to New England.

Henry says fog will cause delays from Boston and the New York City region to Cleveland, Detroit and south to Memphis.

Fog Thursday tangled air traffic in Detroit and Chicago.

About 30% of O'Hare airport's average 300 arrivals and departures each hour were canceled, all flight operations were suspended at Midway. Airports spokeswoman Lisa Howard called O'Hare a "big old slumber party" overnight.

Back on the West Coast, researchers are warning that stress building under Los Angeles could bring earthquakes more damaging than last year's magnitude-6.7 quake.

It killed 61 people and caused $30 billion in damage.

"We think it's likely these faults could produce very large earthquakes," says geologist James Dolan.

And they could be bigger than the fabled "Big One" — a magnitude-8 quake on the San Andreas fault, 30 miles from downtown Los Angeles.

Natural disasters are costing the Golden State a fortune, officials say. Several year's worth of quakes, fires and floods have caused more than $32 billion in damage.

▶ Town digs out, 4A

By Maria Goodavage and Steve Marshall
USA TODAY

---

SHABAZZ: Daughter 'upset'

## Malcolm X kin charged in plot to kill Farrakhan

By Carolyn Pesce
USA TODAY

MINNEAPOLIS — Malcolm X's 34-year-old daughter is to be arraigned next week on charges she plotted to hire a hitman to kill Nation of Islam leader Louis Farrakhan.

Qubilah Shabazz was 4 when she saw her father killed.

Members of Malcolm X's family have long believed Farrakhan was involved in the Black Muslim leader's death.

Shabazz's defense lawyer says the would-be "hitman" was a friend working for the government, and that his client was entrapped.

Shabazz turned herself in Thursday. She was released on $10,000 bond and is scheduled to be arraigned Wednesday.

"She's concerned and upset," says her lawyer, public defender Scott Tilsen.

A nine-count indictment charges she used the phones to develop the scheme and move funds from New York to make a partial payment to the unidentified friend.

If convicted, Shabazz could face up to 90 years in prison and $2.25 million in fines.

U.S. Attorney David Lillehaug says Farrakhan's life was never in danger, and he was told about the investigation.

Three people, two of whom were members of the Nation of Islam, were convicted in Malcolm X's murder. Farrakhan has denied involvement.

▶ 30 years of suspicion, 3A

---

## Nixon gap called intentional

By Gary Fields
USA TODAY

The 18½-minute gap on Richard Nixon's Watergate tapes was intentionally erased by his secretary, says a document newly released by the National Archives.

The document quotes Nixon's lawyers as secretly telling Watergate Judge John Sirica that Rose Mary Woods caused the gap. The memo came from her files.

Last part of a conversation between Nixon and his chief of staff, H.R. Haldeman, the tape was made after the June 17, 1972, breakin at Democratic headquarters in the Watergate.

Nixon, who died last year,

blamed faulty equipment. Three-aide accountant Haldeman said it was "sinister forces."

Leonard Garment, a White House lawyer at the time, says he and colleagues reported finding the gap, but didn't blame Woods. "I'm not sure to this day who tampered with the tape."

Sirica and Nixon biographer Herbert Parmet says blaming Woods is "scapegoating. I stand a rap."

Woods always denied — and was never charged with — wrongdoing. But she testified she may have accidentally caused a four- or five-minute erasure in a series of awkward contortions.

Woods wasn't available for comment Thursday.

*Continued From Page 15*

By the late seventies both *Time* and *Newsweek* had redesigned their formats and overhauled their production departments to accommodate a growing number of color photographs as well as an explosion of colorful information graphics. Advertising strategists suggested that the right mix of both color and black and white advertising could be effective. "Generally speaking, print color advertising forces trust upon the consumer as it is a clear demonstration of power and solidity coming from the producer. On the other hand, black and white ads have a serious and informative trait, they look more factual and discreet. They also represent a change in rhythm in a campaign after a series of color ads and they combat color fatigue."[43]

While newspapers had once dominated the visual presentation of the news, in twenty years television had become king,

and print media were scrambling to catch up. In the early eighties several newspapers followed magazines and began experimenting with full run-of-paper color; The *St Petersburg Times*, the *News of Boca Raton*, (a Knight-Ridder experiment that boasts a pink flamingo on the masthead), and *USA Today*, media giant Gannett's national daily.[44] While the use of bright color in the news and on editorial pages – along with extensive infographics, charts, and lists – was touted as revolutionary for news reportage, it in fact represented a paradigmatic shift from the authoritarian grey papers like the *New York Times* and the *Wall Street Journal* to *The Star* and the *National Enquirer*, tabloids that had for years been running full color signatures and devices like boxed call-outs, bulleted lists, and inset photos. The real revolution was the application of tabloid technique to "respectable" news.

In a 1982 press release announcing the formation of *USA Today*,

Allen J. Neuharth, president of Gannett Company, Inc., promised that the new paper would put into print "some of the excitement, some of the color, some of the graphics, that people are used to seeing on TV screens."[45] The first edition (September 15, 1982) announced that "*USA Today* is designed and edited to be: enlightening and enjoyable to the nation's readers; informative and impelling to the nation's leaders; challenging and competitive to the nation's journalists; refreshing and rewarding to the nation's advertisers."[46] The paper featured a cyan flag, color photography and – *USA Today*'s most imitated feature – a brightly colored full page national weather map.

Reception to *USA Today* was mixed. Circulation shot up to over a million readers in the first nine months of publication and now tops over six million, but the paper has lost over 850 million dollars to date. Response in the journalism community was harsh, and the clipped stories and child-like charts and graphs have earned the dubious distinction of "McPaper," news as fast food. The close association between the marketing and editorial departments of the new papers also raised critics' suspicions. "You want to talk about changing mindset [at the *News of Boca Raton*]" notes one critic. "They plan coverage based on discussions with ad and circulation departments."[47] *USA Today* publisher Tom Curley countered his critics by arguing that market sensi-

tivity is imperative: "*USA Today* is designed to fit the life style of the 90s. It is increasing readership in an age where TV exists."[48]

Perhaps *USA Today*'s most profound effect has been in shaping the look of other newspapers. While managing editor Richard Curtis cites the primary function of color is to differentiate the paper from its competitors, those competitors are quickly closing the gap.[49] Between 1979 and 1983 the number of newspapers printing color more than doubled from 12% to 28%, and by 1986 53% of all weekday papers sported some color.[50] In 1994, 97% of all newspapers ran some color at

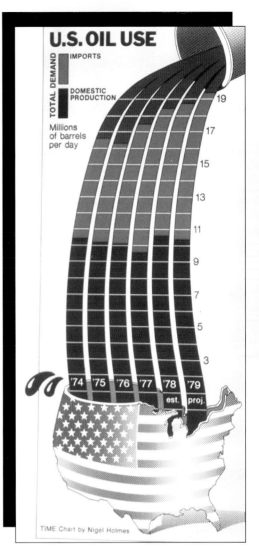

TIME Chart by Nigel Holmes

Infographics by Nigel Holmes

## Some of the excitement... that people are used to seeing on TV screens.

*Continued From Page 17*

least once a week.[51] In a study completed by the Poynter Institute in 1986, the researchers tried to address the issue of colorized newsprint and reader's response. They found that color newspaper pages scored higher than black and white in word-pair comparisons in categories such as interesting/uninteresting, bold/timid, modern/old fashioned, powerful/weak, however, black and white pages compelled readers to spend more time with the actual story. Evoking the familiar intellectual/emotional dichotomy, the report concludes that "color works better for the fast grab, for the quick emotional appeal, but that black and white produces a better response where more in-depth thinking is desired."[52] The researchers speculate "the fact that [*The New York Times, The Los Angeles Times, the Wall Street Journal, the New York Daily News*] use no color may contribute to the notion that 'real' newspapers print in black and white. This research project discovered that the public does not share this prejudice. How can newspaper leaders overcome this myth in their own staffs as they move toward color?"[53]

The Poynter Institute study ends with a vague but ominous warning: "Caveat: The manipulative use of color on news pages has profound political implications."[54] Color is still imagined as a potent reagent that could be dangerous in the wrong hands. Despite concern from within the profession, journalism's "move toward color" is continuing unchecked. The newly refinanced *New York Daily News* will begin color production within two years and even the staid *New York Times*, a paper that limited its use of color to the Sunday Magazine, has steadily introduced it into its other Sunday sections – including the Book Review, the Travel section, and Arts and Leisure, the soft news departments – and will employ full-color printing on the editorial pages of its daily paper by late in 1997. All the major news magazines are now completely color and even the most primitive video from the most remote outpost is broadcast in "living color."

The debate that spins around color is as heated as ever and continues to evolve. Ted Turner's decision to colorize "classic" black and white films such as *Casablanca* and *The Maltese Falcon* for rebroadcast on Turner Broadcast Network raised a furor in the early eighties. Turner argued colorized films would sell better in the television environment than black and white. Jesse Jackson's "Rainbow Coalition" used the spectral metaphor to name a racially inclusive political platform. The same metaphor was utilized with the "Rainbow Curriculum," the ill-fated New York school program that encouraged an inclusive pedagogy addressing the subject of "non-traditional" families. The rainbow has been used in conjunction with subjects as disparate as gay liberation and the user-friendly (i.e. welcoming, inclusive) Apple Computer.

The multiculturalism movement and its emphasis on *mixing* and *coloring* the all-white institutions suggest another application of the constantly shifting political meaning of color, expanding the trope from race to all forms of inclusion. For instance, United Colors of Benetton, the advertising slogan for the Italian multinational corporation that markets knitware under the banner of globalism, and the attendant corporate magazine *Colors*, evoke the same metaphor of diversity. In the recent backlash against multiculturalism and the political correctness, however, spectral metaphors have been recast as signifiers of moral relativity and political uncertainty. Reporting on the Republican victory in the November 1994 election, *New York Times* reporter Maureen Dowd noted that the new Speaker of the House "promised to bury any remnants of what he disdainfully calls the 'Great Society, counterculture, McGovernick' legacy and return America to a more black and white view of right and wrong."[55]

While it may be difficult to predict the exact route, color will continue to infiltrate our media. Already we see it entering the heretofore text-only world of the Internet, personal computers, direct digital video and virtual reality. In its attachment to the "life-like" and the approximation of the "living," the reproduction of color continues to be a goal. The exact meaning of color in and of itself, however, remains elusive.

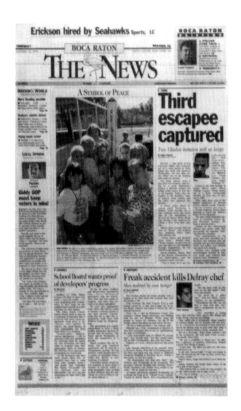

The News of Boca Raton, 1995

From top: Colors magazine; Benetton logo; NBC
peacock logo; Apple computer logo.

## Notes

1 Alfred M. Lee, *The Daily Newspaper in America: The Evolution of a Social Instrument,* (New York: MacMillan, 1937), p.401

2 Ibid, p.401

3 Bill Blackbeard and Martin Williams, *The Smithsonian Collection of Newspaper Comics,* (New York: Harry Abrams, 1977) p.12

4 Lee,*The Daily Newspaper in America: The Evolution of a Social Instrument* p.437

5 Joyce Milton, *The Yellow Kid,* (New York: Harper and Row, 1989), p.17

6 Wilhelm von Bezold, (Boston: Prang, 1876)

7 Finetta Bruce, (London: Rider, 1912)

8 Sir John Gardner Wilkinson, (London: Murray, 1858)

9 David Ramsay Hay, (London: W.S.Orr, 1844)

10 Moses Harris, (Edinburgh: W Blackwood, 1845)

11 Grant Allen, *The Colour-sense; its Origin and Development,* (London: Paul, Trench, Trübner, 1892). p.224

12 Neil Harris, "Color and Media; Some Comparisons and Speculations" from *Cultural Excursions,* (Chicago: University of Chicago Press, 1990) p.323

13 Louis Weinberg quoted in William Leech, *Land of Desire,* (New York: Pantheon,1993), p.172

14 Roland Marchand, *Advertising the American Dream,* (Berkeley: UC Press, 1986), p.118

15 Ibid. p.119

16 Faber Birren, *Selling Color to People,* (New York: University Books, 1956), p.114

17 Newsweek, (July 21, 1934):p.16

18 Neil Harris, "Color and Media; Some Comparisons and Speculations" from *Cultural Excursions,* p.326

19 Newsweek, (June 22, 1935):p.23

20 Roland Marchand, *Advertising the American Dream,* p.123

21 *Newsweek, 60 years...,* corporate promotional brochure

22 Personal conversation with Newsweek staff member Carol Sullivan.

23 Michael Middleton, "Colour Photography in Journalism" in *The Penrose Annual* of 1955, p.86

24 Ibid, p.87

25 C. Maxwell Tregurtha, "Colour Photography in Journalism" in *The Penrose Annual* of 1955, p.97

26 i.e. a free and objective press

27 Maxwell Tregurtha, "Colour Photography in Journalism," p.98

28 Run of paper color refers to color in the actual editorial section of the paper, not in special supplement sections.

29 *Sales Management,* August 15, 1953

30 Faber Birren, *Selling Color to People,* p.113

31 Ibid, p.5

32 Ibid, p.21

33 Ibid, p.113

34 Newsweek (June 22, 1935) p.22

35 Eric de Maré, "The lasting power of black and white," in *Penrose Annual* volume 59, p.38

36 Neil Harris, "Color and Media; Some Comparisons and Speculations" from *Cultural Excursions,* p.333

37 1965 CBS annual report

38 *Sales Management,* November 10, 1963

39 Neil Harris, "Color and Media; Some Comparisons and Speculations" from *Cultural Excursions,* p.333

40 Faber Birren, *Selling Color to People,* p.113

41 Newsweek special issue (January 3, 1977)

42 Newsweek (January 17, 1977) vol.89. no.3

43 Jean Paul Favre, *Color and Communication,* (Zurich: ABC, 1979), p.81

44 The Quill

45 UPI 23 September 1982

46 USA Today September 15, 1982, vol.1, number.1 p.1

47 Quoted in Jay Taylor, "Success Stories?" *The Quill,* Vol.81, No.4, p.24

48 Ibid, p.24

49 Personal interview with Richard Curtis

50 Mario Garcia and Robert Bohle, *Color and Newspapers,* Poynter Institute for Media Studies, 1986, p.32

51 UPI

52 Mario Garcia and Robert Bohle, *Color and Newspapers,* p.43

53 Ibid, p.41

54 Ibid, p.41

55 Maureen Dowd, "GOPs Rising Star Pledges to right the wrongs of the left," New York Times, November 10, 1994, Sect. A, P.1, Col.3.

# Newspapers as Twentieth Century Texture

Kevin G. Barnhurst

**References**

Barnhurst, Kevin G. *Seeing the Newspaper*. New York: St. Martin's Press, 1994.

Howard, Philip. *We Thundered Out*. London: Times Books, 1985.

Hutt, Allen. *The Changing Newspaper: Typographic Trends in Britain and America, 1622–1972*. London: Gordon Fraser, 1973.

Jones, Michael Wynn. *A Newspaper History of the World*. New York: William Morrow, 1974.

*La France Les Etats-Unis et Leurs Presses*. Paris: Centre George Pompidou, 1977.

Lockwood, Robert. *News by Design*. Denver: Quark Press, 1992.

Nerone, John C., and Kevin G. Barnhurst, "Design Change in U.S. Newspapers, 1920–1940." *Journal of Communication* 45.2 (Spring 1995), p. 13–47.

Newspapers reached their apex in the twentieth century, not only in circulation and influence, but also in the visual landscape. Picasso's collages of 1912–1913 incorporated everyday articles on a ground of newsprint, thus identifying the newspaper as the substrate of contemporary life. Artists since then, notably Andy Warhol and Barbara Kruger, have drawn from its form and textures. While the newspaper in novels, television, and film became fixed as an icon, with the look of a 1930s daily, the newspapers people read every day changed visibly.

The twentieth century saw the rise and professionalizing of three fields important to the visual appearance of newspapers: graphic design, advertising, and journalism itself. From journalism came the enthusiasm for news—the faster and more arresting the better. From advertising came the urgency to sell and consume in the marketplace, while design opened newspapers to the influence of the visual arts.

Change did not come easily. News page makeup followed rules whose antecedents can be found in the printed signs, broadsides, and books of the early modern era. Twentieth-century publishers resisted abandoning those traditions, which seemed to embody in visual form the authority of the journalistic craft. Despite great reluctance, newspapers (with a few notable exceptions such as the front page of the *Wall Street Journal*) have accepted new designs in order to compete in the marketplace by looking up-to-date.

This exhibit attempts to classify the visual forms of elite and powerful newspapers. The historical examples come from reproductions available in printed books, most of which deal with the influential U.S. and Western European press. The current newspapers were gathered from libraries and embassies, which tend to subscribe to major newspapers, especially those considered serious.

The following array of current newspapers delineates several dimensions in twentieth-century news design. Three of the dimensions seem crucial to understanding the texture of newspapers as visual phenomena. The range from *vernacular to modern* corresponds to the growing numbers of designers working in journalism and their expanding control over the visual presentation of news. The range from *protomodern to late modern* indicates the entry of style obsolescence into the look of a medium long known for stodgy conservatism. The range from *reserved-classicism to emphatic-expressionism* suggests an expanding vocabulary of visual form that has begun to break down the divide between broadsheets and tabloids.

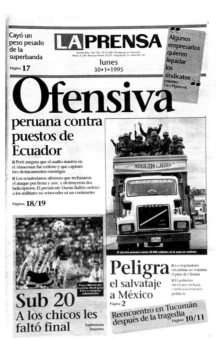

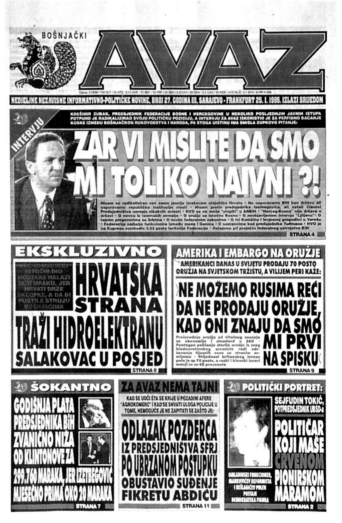

Classicist Modern Broadsheet

Late Modern Tabloid

Vernacular Broadsheet

Modern Expressionist Broadsheet

# Broadsheet Newspapers

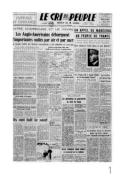

Full-sized newspapers (roughly 14 by 24 inches) are establishment symbols. Their authority comes in part from the huge investments required for the large presses and mechanized papermaking invented in the nineteenth century. A large format has been a sign of authority since the great folio books were first held for serious study at universities. Broadsheets flourished in the twentieth century because they accommodate the modern notion that news should appear in visual priority—from large stories to small, from the top of the page to the bottom, and so forth—all of which requires a format on a grand scale.

## VERNACULAR

Printers, editors, and commercialists have continually produced newspapers without regard to the niceties of typography or the fashions of art. Their vernacular designs visually express the marriage of news and business. Space—always at a premium—is tight or scattered, with elements wrapping cheek-by-jowl around one another. Type is mixed, each headline crafted to fill a hole and jostle its neighbors, shouting to attract purchasers. A range of boxes, borders, and tint blocks vie for the attention of readers. Throughout, the layout makes a rule of inconsistency. These visual signs connote a range of underlying motives—profitmaking and competitive as well as journalistic—well established by Western media.

*Figures*
1. *Le Cri du Peuple du Paris*
   (7 June 1944) reprinted from
   La France, p. 227.
2. *Ghanaian Times* (Accra, Ghana)
3. *New Era* (Addis Ababa, Ethiopia)
4. *Manila Bulletin* (Manilla, Philippines)

*Other Examples*
*Daily Ittefaq* (Dhaka, Bangladesh)
*Times of Zambia* (Lusaka, Zambia)
*Nationalist* (Clonmel, Ireland)
*Egyptian Gazette* (Cairo, Egypt)

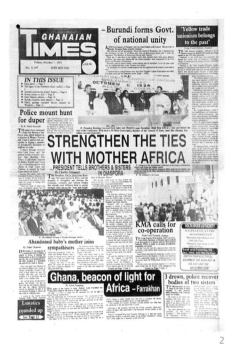

2

3

4

## MODERNISM

The modern movement in newspaper design emerged in the 1920s and 1930s in response to several major currents. The most visually apparent trend was the changing styles in the fine and applied arts. However, shifts in industrial organization based on notions of efficiency and a redefinition of citizens as consumers also contributed to the development of modernism. The organization of news pages responded to an increase in the cultural value of clarity and order in American society as antidotes to not only the manifest disorder of modern war but also the latent terrors of the newly identified unconscious mind.

5

## PROTOMODERN

The first phase of modernism began as early as World War I, when Ben Sherbow began a redesign of the *New York Tribune*. He imposed a single type-face for headlines, combining uppercase and lowercase letters. In a move called "streamlining," John Allen pushed for flush-left, asymmetrical head-lines using type produced by his employer, the Mergenthaler-Linotype Company. Modernist designers also began to view the entire page as a single canvas on which they provided an orderly array—a map—of the day's news from top to bottom. They introduced indexes and summary boxes to guide readers into the paper and, by analogy, into the world itself. This protomodern form of broadsheet newspaper design persists most often in authoritative national newspapers.

6

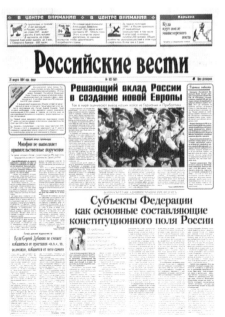

7

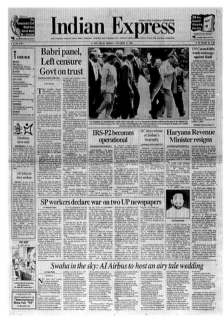

8

## CLASSICIST MODERN

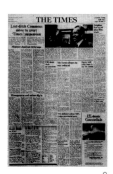

9

In its manifestations in the visual arts, modernism had its Suprematists as well as its Fauves. Likewise modernism revealed several faces in newspapers. The most authoritative of these took on a classical mien. Stanley Morison, who directed the redesign of the *Times* of London beginning in 1929, was influential in the development of the classicist modern style. Classicists admire the refined typography and design clarity of the printed book, and their designs aspire to a similar intellectual status. Although they employ many of the tools of modern design, including indexes, rectangular order, and horizontal layout, they do so with a gray reserve suitable for the voice of authority, sometimes unpunctuated by pictures.

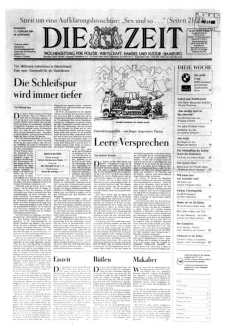

10

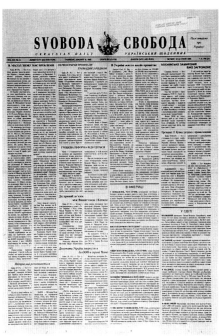

11

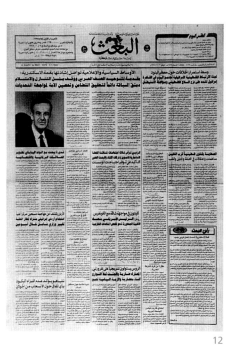

12

*Figures*

9. *The Times* (London, 30 November 1932) reprinted from Howard, p. 125.
10. *Die Zeit* (Hamburg, Germany)
11. *Svoboda* (Jersey City, USA)
12. *Al Baath* (Damascus, Syria)

*Other Examples*
*Tvgodnik Powszechnv* (Cracow, Poland)
*Neues Deutschland* (Berlin, Germany)

## HIGH MODERN

When it reached its height in the 1970s, modernism reduced the complexity of the news page to a series of rectangles (sometimes erroneously called modules). Newspaper publishers hired consultants, such as the British artist Frank Aris and the graphic designer Massimo Vignelli, to accomplish redesigns based on Swiss-style grids. The horizontal form dominated layouts. Indexes and summary boxes grew in importance along with promotional items, called sky boxes, meant to entice the reader to look inside. Larger display type and dominant images, often in color, imposed a simple order on the few remaining page-one stories. Most U.S. broadsheets fit into this category.

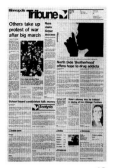

13

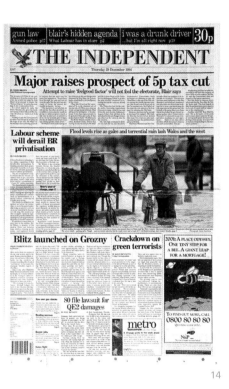

14

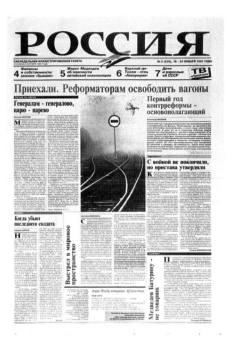

15

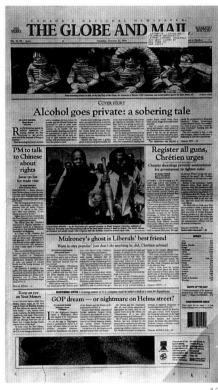

16

*Figures*

13. *Minneapolis Tribune* (Minneapolis, USA, 1971) reprinted from Hutt, p. 213.
14. *The Independent* (London, England)
15. *Rossia* (Russia)
16. *The Globe and Mail* (Quebec, Canada)

*Other Examples*
*Central Daily News* (Taipei, Taiwan)
*Prague Post* (Prague, Czech Republic)
*Le Devoir* (Montréal, Canada)

## LATE MODERN

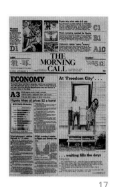

17

When the Society of Newspaper Design organized in 1979, newspapers had already entered a new phase. Many of the modernist urges continued: from advertising, more promotional strategies, boxed items meant to "sell" the stories inside; from journalism, more mapping techniques, indexing and ranking the news content; and from design, more visual structures, seeking control-by-rectangle within a grand (and more or less fixed) architectural page design. Designers tempered modernism with what might be considered post-modern borrowings from older newspaper styles: more maps and informational graphics, an increased typographic contrast, a higher "story count," and a smaller scale overall for pictures and other elements. *USA Today* is probably the best known example of a style that preceded its founding in 1982 and has flourished since.

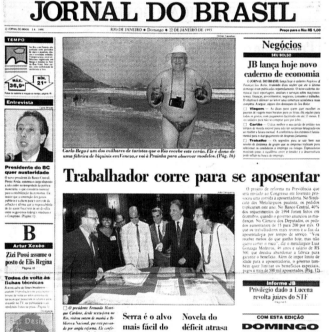

18

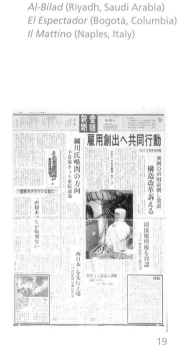

19

*Figures*

17. *Morning Call* (Allentown, USA, 23 May 1980) reprinted from Lockwood, p. 47.
18. *Jornal do Brasil* (Rio de Janeiro, Brazil)
19. *Sankei Shimbun* (Tokyo, Japan)

*Other Examples*

*San Jose Mercury News* (California, USA)
*USA Today* (Washington, D.C.)
*Politiken* (Copenhagen, Denmark)
*Berita Harian* (Kuala Lumpur, Malaysia)
*Al-Bilad* (Riyadh, Saudi Arabia)
*El Espectador* (Bogotá, Columbia)
*Il Mattino* (Naples, Italy)

# Tabloid Newspapers

Small format newspapers (roughly half the dimensions of a broadsheet) have existed since the earliest news sheets appeared in Germany in the seventeenth century, and serious, authoritative newspapers continue to publish in small formats. However, the screaming tabloid is a twentieth-century invention, usually dated from the founding of the *Daily Mirror* in 1903. Within its small size, a tabloid adopts a moral, rather than an intellectual, view of the world. Tabloids divide less clearly into categories than broadsheets do, except when mimicking the modern forms of broadsheets. Because they are more varied, tabloids are also more interesting as design innovators.

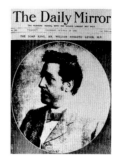

20

## VERNACULAR

Some tabloids show very little apparent influence from artists. Vernacular tabloids present a wide range of visual moods, from the most anguished to the most calm. This continuum, with emphatic forms at one extreme and reserved forms at the other, illustrates another dimension of twentieth-century newspapers. Like the vernacular broadsheet newspapers, these designs mix typefaces willy-nilly and lay out stories so that one wraps around another, using inconsistent boxes, rules, and colors to present separate content. This naive use of design form holds across the spectrum of vernacular newspapers, from the emphatic to the reserved.

*Figures*
20. *Daily Mirror* (London, 27 October 1906) reprinted from Jones, p. 60.
21. *La Tribuna* (Tegucigalpa, Honduras)
22. *Al-Khabar* (Algeria)
23. *New Nigerian* (Lagos, Nigeria)
24. *Trybuna* (Warsaw, Poland)

*Other Examples*
*Slobodna Dalmacija* (Croatia)
*Moskovskoye Vremya* (Moscow, Russia)
*Barbados Advocate* (St. Michael, Barbados)
*Cameroon Tribune* (Yaounde, Cameroon)
*Blitz* (Bombay, India)
*Nova Bosna* (Bosnia, Herzegovina)

Emphatic ← → Reserved

21

22

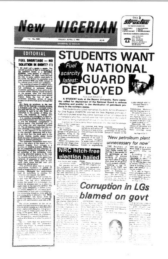

23

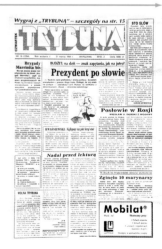

24

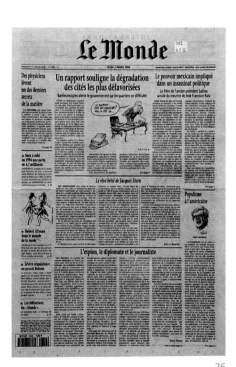

## MODERNISM

The visual modes of modern newspaper design appear to have entered primarily the authoritative tabloids (or those with ambitions to that status). As a result, the categories are similar to those found in modern broadsheets. Because of the limits of the format, tabloids have adopted modernism only partly, and the stylistic differences are not as clearly demarcated as they are in broadsheets.

## PROTOMODERN

Small-format newspapers that aim for the same tranquillity as serious broadsheets use fairly large amounts of gray text. They adopt some but not all of the features of modernism: uppercase and lowercase headlines, fairly uniform typefaces, rectangular shaped layouts, indexes, promotional items, and a larger scale. The authority of these newspapers produces more fixity of design than is found in other tabloids. Publishers apparently resist tampering with what has worked, and that success stymies the arguments for following the avant garde.

25

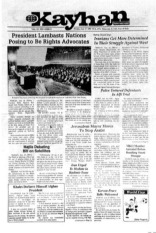

26

27

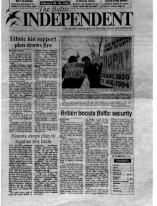

28

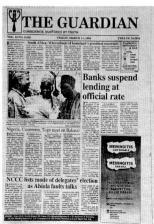

29

*Figures*

25. *Newsday* (Long Island, USA, 21 July 1969) reprinted from Hutt, p. 209.
26. *Le Monde* (Paris, France)
27. *Kayhan* (Tehran, Iran)
28. *The Baltic Independent* (Estonia)
29. *The Guardian* (Lagos, Nigeria)

*Other Examples*

*Straits Times* (Singapore)
*Argumenty e Facty* (Moscow, Russia)

# MODERN

Modern tabloids are contradictory vehicles for moral outrage. The uniform typefaces and neat, rectangular layouts suggest a logical clarity; but the large scale headlines and pictures suggest more passion within the constraints of the small page. Because of limited space, modern tabloids less clearly impose a hierarchical map than broadsheets do. The neatness still allows for more than one story on each page, but the few stories that remain paint only part of the larger maps seen on broadsheet front pages.

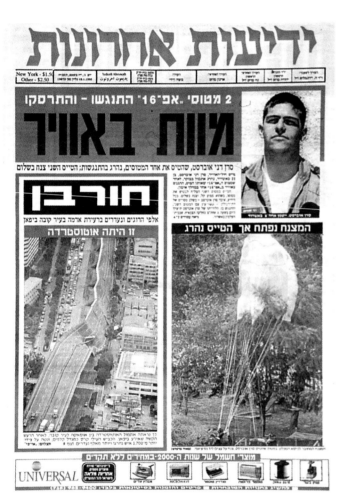

30

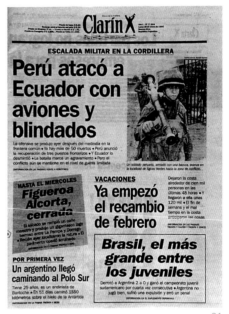

31

32

*Figures*

30. *Yedioth Ahronoth* (New York, USA)
31. *Clarin* (Buenos Aires, Argentina)
32. *Weekly Mail & Guardian* (South Africa)

## LATE MODERN

Late modern tabloids are more like their broadsheet counterparts than like tabloids. They employ charts and graphics, contrasting type, and many small items that are thoroughly indexed and well promoted, with all the elements squeezed into the smaller, tabloid format. The space used by all these organizing and publicizing devices further reduces the scale of everything else, including the screaming headlines and shocking pictures. Within these limits, late modern designs still span a range from somewhat emphatic to somewhat reserved.

Emphatic                                             Reserved

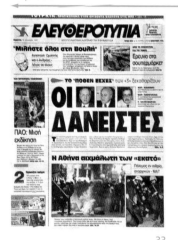

33

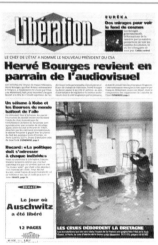

34

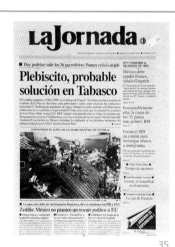

35

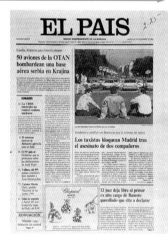

36

*Figures*

33. *Eleftherotypia* (Athens, Greece)
34. *Libération* (France)
35. *La Jornada* (Mexico City, Mexico)
36. *El País* (Madrid, Spain)

*Other Examples*
*Dagbladet* (Oslo, Norway)
*La Tercera* (Santiago, Chile)
*La Repubblica* (Rome, Italy)

# MAGAZINE

Magazine-style tabloids recall somewhat the early newspapers that used the front page as a cover, emphasizing a single story. Broadsheets will dedicate an entire page only rarely to a single story, and then only for coverage of historic events. In their current form, magazine-style tabloids descend from the *Newsday* of the 1970s. Tabloids that resemble magazines follow the modern convention of treating the page as a canvas, but often without many of the promotional and organizational devices of modernism. The use of long stretches of text, especially on the interior pages, harkens back to classically designed newspapers. These design techniques correspond to the rhetorical (or polemical) and counter-establishment positions often found in the editorial content of these newspapers.

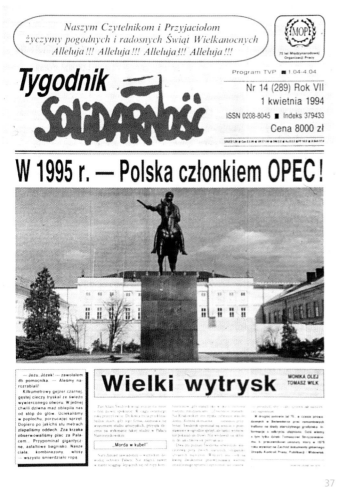

37

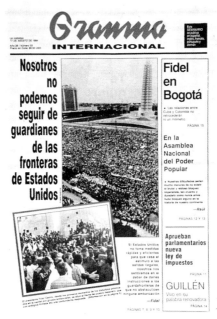

38

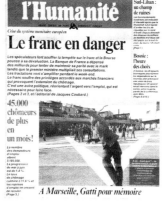

*A Marseille, Gatti pour mémoire*

39

# Expressionist Broadsheets

Just as modernist notions spread to the tabloids, emphatic modes of design have invaded the broadsheet format, bringing the chain of influence full circle. The expressionist broadsheet is less common in Western countries where format is defined by the content distinctions that still reign supreme between broadsheets and tabloids.

### VERNACULAR

In its vernacular form, the emphatic broadsheet mixes type exuberantly and juxtaposes all manner of decorative borders and boxes in irregular shapes. The large scale of the page makes these the most expressionist of newspaper designs.

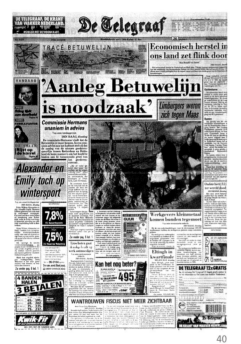

40

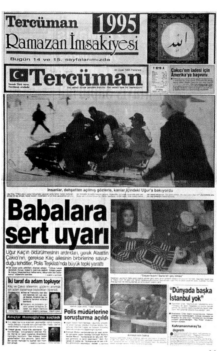

41

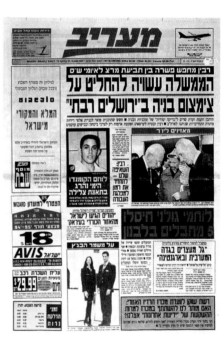

41

**Figures**
40. *De Telegraaf* (Amsterdam, The Netherlands)
41. *Tercüman* (Frankfurt edition)
42. *Maariv Israeli Daily* (New York edition)

**Other Examples**
*Demokrazia* (Sophia, Bulgaria)
*Romania Libera* (Bucharest, Rumania)

## MODERN

Some expressionist broadsheets are hybrids that use the cool of modern design along with the heat of the screaming tabloid. Their designers combine unified type, neat rectangles, and the promotional and mapping strategies of modernism with the high-contrast emphatic modes of the tabloid, all on a broadsheet page. The result most closely resembles late-modern-style tabloids.

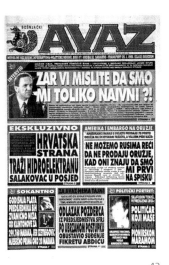
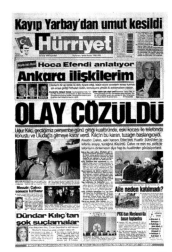

43

44

*Figures*
43. *Avaz* (Sarajevo, Bosnia)
44. *Hurriyet* (NewYork edition)
45. *France-Soir* (Paris, France)

*Other Examples*
*Bih Ekskluziv* (Split, Croatia)

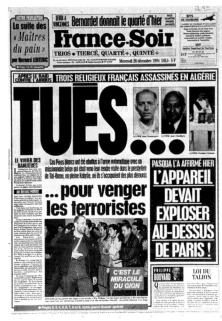

45

## POSTSCRIPT

Any effort to categorize news designs has limits and glosses over shades of variation, some of the most interesting of which occur between rather than within categories. One pattern that only partly shows through the stylistic organization of this exhibit is a sort of linguistic regionalism. Designs of newspapers in a single language tend to resemble each other. Chinese characters produce textures visually unlike Cyrillic or Devanagari script, no matter who designs with them. However, the parallels go beyond those motivated by different alphabets.

Newspapers also seem to follow national or cultural schools of design. Many of the newspapers from the Indian subcontinent, for example, share a preference for proto-modern design, down to the use of Bodoni-inspired headlines. The region spanning central Europe, Asia Minor, and central Asia seems to have led the way toward expressionist broadsheets. Europe specializes in serious, intellectual tabloids, and so forth. This tendency accounts for the much maligned "cookie-cutter" uniformity of broadsheets in larger U.S. cities, which are high (verging on late) modern in design.

Left out of this discussion of elite newspapers is the demotic world of supermarket tabloids, throwaway advertisers, and fringe weeklies. The power of these descendants of yellow journalism is more difficult to document, but worth the effort, because their circulation often outstrips the prestige press. Although superficially bereft of reasoned discourse (and of any particular concern for factuality), these tabloids may exercise authority through the moralizing tones of scandalized (if titillated) popular will.

The existence of this antithesis, if anything, enhances the rational power and political influence of the serious newspapers displayed here. Today the news media seem to drive public policy, and their visual dimension predominates, making national elections personal and local court proceedings global. The prestige press requires close scrutiny because, despite predictions of imminent demise, these newspapers remain the most authoritative of media forms.

# BRAND NEWS

## By Lawrence Mirsky

The tabloid *News of the World* is as anonymous in relation to its owner, The News Corporation Limited, as Time-Warner is synonymous with *Time* magazine. Both publications express the personalities and interests of their parent corporations whose holdings include a vast array of broadcast stations, film and electronic services, and newspapers, each possessing varying degrees of visual autonomy and independence. *Time* circulates twenty-two million issues a week through international editions distributed in Asia, Australia, Europe, Canada, and Latin America, while *News of the World* circulates 4.8 million. What the Supreme Court Justice Louis Brandeis once described, in 1916, as an "endless chain" of interlocking directorates is now fused in the electronic crucible of a highly concentrated media.[1] The density of these concentrated properties resembles a "clip art" style of ownership that may accurately represent the entities without clearly defining them.

For a media corporation with widely diversified interests, an entire corporate subdivision may be treated as a brand product. In the global economy a company uses a brand in lieu of a handshake. The brand trademark serves as a personal introduction to a new community establishing a value for a

The series of spreads above is drawn from the 1994 Annual Report of The News Corporation Limited. The images represent a cross-section of the media corporation's holdings.

product that transcends its basic utility. The increasing value of these trademarks is evident in the recent spate of treaty negotiations that seek to simplify and unify the criteria for registering these marks worldwide.

Below the generic logo of The News Corporation is an array of companies that are not designed to draw attention to their parent entity. The names of The News Corporation's properties are as general as the holdings they manage: The News Limited, News America, News Finance, News Group Newspapers Limited. By using such common terms to name its consolidated group of accounts, the corporation maintains a low profile and institutionalizes its anonymity.

As the pace of acquisitions and mergers accelerates, it becomes increasingly difficult to identify and track these parent companies and their holdings. A corporate identity program establishes a visual system of trademarks for a company to communicate its message and image to the public. A trademark for a parent corporation may consist of "any combination of words, slogans, symbols, or devices that identify the source or origin of a product."[2] Trademarks also include service marks for identifying services and collective marks for identifying "goods, services or members of a

collective organization."[3] The logotypes for *The New York Times* and *Time* magazine are both trademarks. These essentially grammatical devices document a company's pattern of activity. Our highly competitive global economy challenges the elasticity of corporate identity and traditional forms of centralized design management. The concision, order, and continuity of an identity system could, in the context of today's seamless corporations, function as an essential public service by clarifying the ownership, authorship, and origin of images both found and invented by these companies.

Tracing the design continuity and discontinuity among newspapers, magazines, and newscasts within and between global media corporations exemplifies a variety of *monolithic*, *endorsed*, and *branded* affiliations. These relationships demonstrate varying degrees of corporate accountability, ambiguity, and anonymity. Corporate identity strategist, Wally Olins, describes *monolithic* identity as, "one name and visual style" associated with a company.[4] The "Eye" of the Columbia Broadcasting System, designed by William Golden in 1959, is one of the most well known *monolithic* forms of identity. The longevity and consistency of the CBS "Eye" has established a high visibility for the company and, as with most broadcast networks, a corresponding level of accountability.

An *endorsed* identity structure consists of constituent parts of an organization that are identifiable on their own, but are also seen "as part of a larger whole," while a *branded* company "operates through a series of marks or names that may be unrelated either to each other or to the corporation."[5] By severing all visual associations with its parent corporation, a media outlet can establish the appearance of journalistic and economic independence. A corporation can either be fragmented by default or segmented by design, but the net result is a decentralized structure with an anonymous composition. Designed disassociations offer media organizations the opportunity

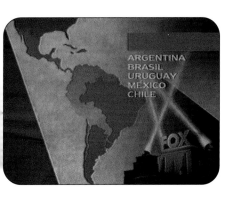

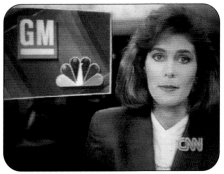

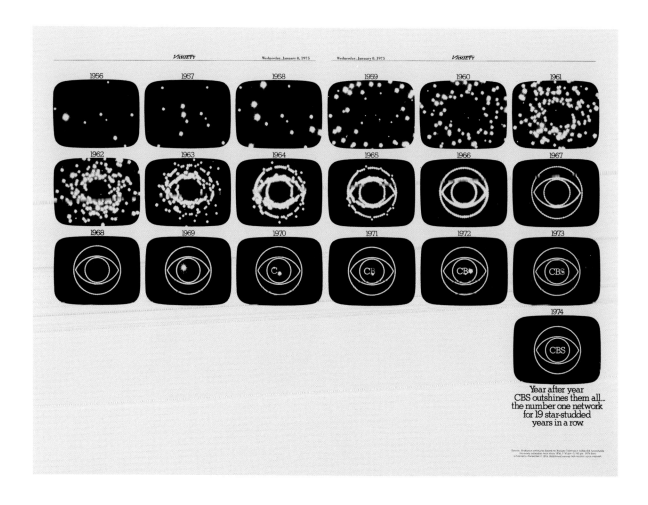

to collaborate through what one might describe as "invisible endorsements," the association of two independently or jointly owned brands with no obvious connection. The inherent flexibility of a branded identity offers a parent company infinite latitude in organizing its marketing strategy. In contrast, broadcast networks institutionalize self-endorsement. Morning, noon, and night broadcast trademarks rest in a corner of the television screen, to help protect the copyright of each network's news footage. Rather than functioning as symbols for the newscast itself, these trademarks represent the totality of the network's programming, illustrating the structural convergence of news and entertainment identities.

This convergence also occurs when corporate trademarks are aired during a newscast and in commercials between news segments. Any "bad news" associated

This advertisement designed by Lou Dorfsman during his forty-year tenure at CBS celebrates the network's record of achievement over nineteen years. The success was due in part to the centralized management of design under the stewardship of Frank Stanton, former president of CBS. Today, as corporate mergers and acquisitions challenge the corporate identity of all broadcast companies, the advertisement might be read from back to front.

with a logo is often contradicted by its formal elegance. As a result, the trademark can appear as an unedited visual quote or an endorsement by the network. A soft news item in *Time* magazine illustrates a version of this practice. This insert in *Time* highlighted the commercialization of radical songs from the sixties, but also featured the logo for Ford, a major advertiser in Time Inc's weekly publications.[6] The *Time* logotype also appeared in the brief entry. This form of self-endorsement also occurs on the pages allotted exclusively for advertising.

The *line-extension* of a brand is a synthesis of monolithic, endorsed, and branded identities that adapt an original identity design to different markets. This approach is common among film companies entering the realm of television. The Twentieth Century Fox Film Corporation is one of the few properties owned by The

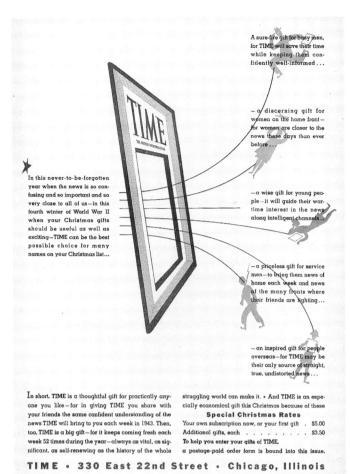

The signature red frame of *Time* magazine was introduced in January of 1927. The first full color cover appeared two years later.

 ➡

The cropped beams of light in the television logo (center) are emblematic of the anonymous identity of The News Corporation.

News Corporation with *brand equity*. The term refers to the intangible assets of a corporation such as its image. The monetary value of this image may actually serve as collateral in a financial transaction. The value is determined by estimating the sum total of all advertising and staff time invested in a product over its lifetime. In the case of Twentieth-Century Fox, the logo was redesigned for a series of related production companies, including Twentieth Television Productions, the affiliated broadcast stations of the Fox Television Network, and the new entertainment channel, "fx."

The cropped version of the Fox symbol is an awkward attempt by the The News Corporation to challenge the tradition, visual appeal, and brand equity of its competitors. The newly formed association between The Fox Broadcasting Company and Reuters News Service, founded in 1881, is an attempt to acquire the respectability and brand status held by long-lived companies such as *Time*. The high profile and bombastic reputation of The News Corporation's chief executive officer Rupert Murdoch is the closest the company comes to approaching a monolithic identity, but his association with particular products is more anecdotal than the systematic sensationalism he promotes.

Hispano Fox Film S.A.E.
Hoyts Fox Columbia Tri-Star Films Pty. Ltd.
International Classics Inc. (liq)
Janpra Productions Inc. (Formerly 20th Century Fox of Ecuador)
LAPTV A Corp.
LAPTV B Corp.
Les Productions Fox Europa S.A.
Magnetic Video Inc.
Mirror Pictures Corporation
Monet Lane Prod. Inc.
Morning Glory Productions S.A. de C.V.
Morning Studios, Inc.
Movietone news Inc.
MPC Producers Inc. (liq)
MVP Video Productions Inc.
NA Property Holdings Inc.
National Studios Inc.
NENQ Inc.
Netherlands Fox Film Corp. B.V.
News Air Nevada, Inc.
News Aviation Nevada, Inc.
News Germany Holdings G.m.b.H.
News Preferred Finance Inc.
Newscorp Finance Ltd.
Night Movie Music, Inc.
Northgate Productions, Inc.
O/Y Fox Film A/B
Panoramic Productions Inc.
Pico Films Inc.
Prime Time Media, Inc.
Produzione Artistiche Internazatonali
Puerto Rican Film Service
Repaca, Inc.
Rewind Music Inc.
SC Productions, Inc.
SCPI, Inc.
SF Broadcasting L.L.C.
Sprocket Music Inc.
STF Distributing Inc.
TCF Distributing Inc.
TCF Music Publishing Inc.
TCFC Film Distribution Co. B.V.
TCFM Corp. (liq)
TICI Productions Inc.
TVP Productions Inc. (formerly 20th Century Fox Burma Inc.)
Twentieth Century Fox International TV
Twentieth Century Fox Asia Pacific Telecommunications L.L.C.
Twentieth Century Fox Asia Pacific Theatrical L.L.C.
Twentieth Century Fox (Canada)
Twentieth Century Fox Distributing Corp.
Twentieth Century Fox Entertainment Inc.
Twentieth Century Fox Federal Inc.
Twentieth Century Fox Belge S.A.
Twentieth Century Fox Film Co. Ltd.
Twentieth Century Fox Film Co.
Twentieth Century Fox Film Corp. (export) Ltd.
Twentieth Century Fox Film Corp. S.d E Pla S.
Twentieth Century Fox Film de Mexico S.A.
Twentieth Century Fox Film Distributors Hellas SARL
Twentieth Century Fox Film S.A.
Twentieth Century Fox Film

News America Finance Inc.
News America FSI, Inc. (formerly FSI Operations Inc.)
News America Publ. Inc. (formerly Triangle Publ. Inc.)
News America Real Estate Inc.
News Group Boston Inc.
News Group Chicago Inc. (sold)
News Group Electronic Publ. Inc. (sold)
News Group Enterprises Realty Corporation
News Group Graphics Inc.
News Group Production Inc. (liq)
News Group Publ. Inc. (liq)
News Group Realty Corp.
News Group/Times Newspapers UK Inc.
News Ltd. of Australia, Inc.
News Triangle Finance Inc.
Newsflight Inc.
NYP Holdings, Inc.
Rugged Ltd.
San Antonio Film Features Inc.
Scott Acquisition Corporation (liq)
Skyband Inc.
Sun-Times Sales Corp. (liq)
TCF Holdings Inc.
TENC Inc.
The Express-News Corp.
TV Guide Finance Inc.
Twentieth Century Fox Inc.
VSI Publ. Corp. (sold)
WFXT Inc. (sold)
World Printing Company Inc.
World Publ. Services Inc (liq).
News Air Nevada, Inc.

**Twentieth Century Fox Film Corp.**
Twentieth Century Fox Film International Corp.
Aktiebolaget Fox Film (formerly Fox Film A/B)
Anglo-American Film Dist. Ltd.
Ancon, Inc.
Angal, Inc.
Angar, Inc.
British Movietonews Ltd.
CBS / Fox French Film Licensing Corp.
Centfox Film, GES m.b.H.
Cinemas Fox-Severlano Ribeiro Ltd
CinemScope Products Inc.
Columbia-Fox O.E.
De Luxe Laboratories Film Storage Inc.
De Luxe Laboratories Inc. (liq)
Distribuidora Difox C.A.
Drive-In Cinemas Ltd D.A.W. Productions Ltd
EPS Entertainment Programming Services Ltd
Evergreen TV Productions Inc.
FA Productions, Inc.
Film. Distributors Assoc. 35 MM Ltd.
Filmlets (East Africa)Ltd.
Fox Animation Studios Inc.
Fox Center Productions Inc.
Fox Children's Music Inc.
Fox Children's Network, Inc.
Fox Children's Productions, Inc.
Fox Circle Productions Inc.
Fox Columbia Tri-Star Films Pty. Ltd
Fox. Development Group Inc.
Fox. Electronic Publ., Inc.
Fox Exports Inc. (liq)
Fox Film A/S
Fox Film A/S

Tapley-Rutter Co. Inc
Zondervan International, Inc.
Zondervan Leasing Corp.
**HARPER AND COLLINS (UK) LTD.**
Harper and Collins Investment (UK) Ltd.
Harper and Collins BV
Collins Audio Video Supply Pty. Ltd
**Collins Desktop Publ. Ltd.**
**Harper and Collins Holdings BV**
**Harper Collins Finance BV**
**William Collins Holdings Ltd.**
Harper Collins Publ. Inc. (liq)
Marshall Pickering Holdings Ltd.
Marshall Morgan & Scott Publ. Ltd
Pickering & Inglis Ltd.
The Lamp Press Ltd.
William Collins Inter. Ltd.
Harper Collins Publisher (New Zealand) Ltd.
William Collins Publisher Ltd.
Allen & Unwin New Zealand Ltd
Angus & Robertson Publ. (NZ) Ltd.
Golden Press (NZ) Ltd.
Williamson Jeffrey (Aust) Pty. Ltd.
Windsor Watt Ltd. (liq 1994)
HarperCollins Canada Ltd.
Harper Collins Publishers (SA) Pty. Ltd.
William Collins Jersey (Holdings) Ltd
HarperCollins Publ. (Australia) Pty. Ltd.
Dovcom Nominees Pty. Ltd.
Dove Communications Trust
Collins/Angus & Robertson Publ. Pty. Ltd.
Kananga Pty. Ltd.
HarperCollins Publ. Pty. Ltd.
Harper Educational (Australia) Pty. Ltd.
Harper & Row (New Zealand) Ltd.
Book and Film Services Ltd
Golden Press Pty. Ltd. (sold 1993)
William Collins Sons & Company Ltd.
Collins Netherlands Finance BV
Harper Collins Publisher Asia Pty. Ltd
William Collins Ltd.
Cartographic Services (Cirencester) Ltd.
Cobuild Ltd.
Dinosaur Publications Ltd.
Hill MacGibbon Ltc.
Davis Poynter Ltd (dereg 1993)
William Collins Ltd (dereg 1993)
Pollokshields Printing Services Ltd
Atlantic Book Publ. Co. Ltd.
Coat of Arms Ltd.
William Collins Ltd. (dereg 1993)
Elek Books Ltd. (dereg. 1993)
Grafton Books Ltd.
Harvill Press Ltd
William Collins Ltd. (dereg. 1993)
Mayflower Books Ltd. (dereg. 1993)
Paul Elek Ltd. (dereg 1993)
Rupert Hart-Davies Ltd. (dereg 1993)
Westerhill Distribution Services Ltd. UK (dereg 993)

Star Advertising Sales Ltd. (formerly News Data Security Products)
**News Datacom Inc.**
**News Datacom Ltd.**
News Daracom Pty Ltd.
**News Financial Services Ltd.**
**News Group Newspapers Ltd.**
**News Germany Holdings GmbH**
Twentieth Century Fox Germany GmbH
Twentieth Century Fox Austria GmbH
Fox Video Germany GmbH
News Haroer Ltd. (liq 12/93)
**News International Distribution Ltd.**
**News International Exhibitions Ltd.**
**News International Associated Services Ltd.**
**News Inter. Newspapers Ltd.**
**News Inter. Supply Co. Ltd.**
**News Inter. TV Investment Co. Ltd.**
**News Inter. TV Ltd.**
**News Inter. (advertisement) Ltd.**
**News Inter. Newspapers Scotland) Ltd.**
**News Inter. Pension Trustees Ltd.**
**News Investments UK Ltd.**
**News Notes Ltd.**
**News of the World Ltd.**
**News Offset Ltd.**
**News Promotions Ltd.**
**News SMS Ltd.**
**News Telemedia Europe Ltd.**
**News (UK) Ltd.**
**NGN Editorial Pension Trustees Ltd.**
**NGN Editorial Executive Trustees Ltd.**
**NGN Staff Pension Trustees Ltd.**
O-dinto Investments Ltd.
**Planned Precision Ltd. (liq Jan 1994)**
Radio 538
R&R Films Ltd. (liq 1/94)
SA Sky Channel NV
Salcombe Securities Ltd.
Satellite Marketing and Advertising Ltd.
Satellite TV GmbH
Shoppers Friend Ltd.
Sky Channel Ltd.
Sky Channel AG
Sky Channel SRL
Sky Radio Ltd.
Satellite Television Ltd. (liq Jan 1994)
Sun Day Publications Ltd. (liq Jan 1994)

NPL Ltd. (formerly Asher & Co. Hong Kong Ltd.)
Asher & Co. (Hong Kong) Ltd. (formerly Yee Tin Tong Printing Press Ltd.) (sold 1993)
**News Finance (HK) Ltd. (sold 1994)**
**News Investment (Caymen) Ltd.**
**News Finance (Caymen) Ltd.**
South China Morning Post (Holdings) Ltd. (sold 1994)
South China Morning Finance (Caymen) Ltd.
**South China Morning Post (Caymen) Ltd.**
Pan-asia Book Distributors Ltd.
South China Morning Post Investment (Caymen) Ltd.
**South China Morning Post Enterprises (Caymen) Ltd.**
**South China Morning Post Consolidated (Caymen) Ltd.**
**South China Morning Post Publishers Ltd. (sold 1994)**
**South China Morning Post Pty Ltd. (sold 1994)**
**Wai Kiu Yat Po Ltd. (sold 1994)**
**STAR TELEVISION LIMITED**
Adina Ltd.
Agar Ltd.
Alcado Ltd.
Alicia Ltd.
Altaea Ltd.
Antice Ltd.
Asian Music Corporation Ltd.
Beaver Assets Ltd.
Berer Ltd.
Birns Ltd.
Boetin Ltd.
Brannan Ltd.
Bremmant Ltd.
Carney Ltd.
Dimple Investment Ltd.
Don Bluth Ireland Ltd.
Don Bluth Ltd.
Don Bluth Music Publishing Ltd.
Fieldmouse Production Ltd.
Irvine Services Ltd.
Jitterbug Assets Ltd.
Macoy Properties Ltd.
Media Assets BVI Ltd.
Media Assets Ltd.
Mbonglow International Ltd.
Musical Moles Ltd.
News Television India Private Ltd.
Penda Jade Ltd.
Satellite Television Asian Region Ltd.
Syhill Enterprises Ltd.
Seedy Hero Ltd.
Star Television Asia Ltd.

**THE NEWS CORPORATION LTD.**
**NEWS U.S. HOLDINGS PTY. LTD.**
**News Group Holdings Pty. Ltd.**
**ACCESS SECURITIES PTY. LTD.**
**NEWS LIMITED**
**Advertiser-News Weekend Co. Pty. Ltd.**
**ALW Pty. Ltd.**
**Arrameur Pty. Ltd.**
**Bosomir Pty. Ltd.**
**Boscage Pty. Ltd.**
**Broadsystem Pty. Ltd.**
**Chadpalm Pty. Ltd.**
**CPG Investments Pty. Ltd.**
**Festival Records Pty. Ltd.**
Crown Music Publishing Pty. Ltd.
Festival Manufacturing Pty. Ltd.
Festival Music Pty. Ltd.
Festival Records NZ Ltd.
Festival Records & Sales Distribution Pty. Ltd.
Festival Records International Ltd.
F.S. Falkiner & Sons Ltd.
F.S. Falkiner & Sons (Queensland) Pty.
F.S. Falkiner & Sons (Wanganella) Pty.
**Ionclip Pty. Ltd.**
**Lenwage Pty. Ltd.**
**Mirror Newspapers Ltd.**
Bay Publishing Group Pty. Ltd.
Sky Cable Pty. Ltd.
Festival Books and Associates Ltd
Publishing Associates Ltd.
Maydepa Pty. Ltd.
Festival Record (Wholesale) Pty. Ltd.
Winston Investment Pty. Ltd.
**Nationwide News Pty. Ltd.**
Angus and Robertson (New Zealand) Ltd
Australian Indoor Tennis Championships Pty. Ltd.
Control Investments Pty. Ltd.
B.B.A.C. Pty. Ltd
Fromane Pty. Ltd.
Lorgi Pty. Ltd.
News Press (NZ) Ltd (in liquidation)
Spectak Productions Pty. Ltd.
The Sydney Suburban Newspaper Co. Pty. Ltd.
The North Queensland Newspaper Co. Ltd
A.C.N. 099 655 681 Pty. Ltd.
Ayr Newspapers Pty. Ltd.
Far North Publishing Co. Pty. Ltd.
N.Q.N. Investments Pty. Ltd.
**News NT Investments Ltd.**
**The News (Adelaide) Pty. Ltd.**
**A.C.N. 004 261 670 Pty. Ltd.**
Kipson Pty. Ltd.
**Sparad (No. 9) Pty. Ltd.**
**Trebee Pty. Ltd.**
**Tejeku Pty. Ltd.**
**Terrace Investments Pty. Ltd.**
Cumberland Printers Pty. Ltd.

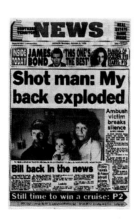

Twentieth Century Fox Film Corp. (Aust.) Pty. Ltd.
Votraint No. 606 Pty. Ltd.
**Wespre Pty. Ltd.**
Art Photo Composition Pty. Ltd
Country Job Printing Pty. Ltd.
**The Herald and Weekly Times Ltd.**
A.C.N. 000 024 028 Pty. Ltd
Pacific Publications (Fiji) Ltd.
F.T.H. Properties Ltd.
Fiji Times Ltd.
Advertiser Newspapers Ltd
Advertiser Securities Pty. Ltd.
A.C.N. 006 324 885 Pty. Ltd.
Bomen Pty. Ltd
Lomax Pty. Ltd
Messenger Press Ltd.
Queensland Tourist Publ. Pty. Ltd.
Allied Press Pty. Ltd.
Post Courier Ltd.
South Pacific Post Pty. Ltd.
Central Coast Publications Pty. Ltd.
A.C.N. 004 747 353 Pty. Ltd.
Davies Brothers Ltd.
Fungible Pty. Ltd (in liq.)
HWT (N.S.W) Pty. Ltd.
Lisrich Pty. Ltd.
Leader Media Group Pty. Ltd
Leader Associated Newspaper Pty. Ltd.
Broadglen Publishing Co. Pty. Ltd. (Liq)
A.C.N. 006 252 142 Pty. Ltd.
Standard Newspaper Ltd.
Southern Peninsula Gazette Newspapers Pty. Ltd. (liq)
Sturdee Pty. Ltd.
Television Broadcasters Investments Pty. Ltd.
Wanban Ltd

**NEWS SECURITIES B.V.**
**News Aluminum Ltd.** (dereg. 1993)
**News Group Credits Netherlands Antilles N.V.** (sold 1993)
**NEWSCORP SECURITIES LTD.**
**NEWS PUBLISHERS HOLDINGS PTY. LTD.**
**News Publishers Investments Pty. Ltd.**
News Caymen Holdings Ltd
**News Air Hong Kong Ltd.**
**News Caymen Ltd.**
**News Caymen Finance Ltd.**
**News Caymen Investment Ltd.**
**Newscorp Caymen Islands Ltd.**
**Newscorp Caymen International Ltd.**
**Newscorp Overseas Ltd.**
**News Datacom Research Ltd.**
**News Publishers Finance Ltd.** (sold 1994)
**News Caymen Ltd.**
**NPL Investments I** (Caymen) Ltd.
**NPL Investments II** (Caymen) Ltd.
**News Printing Ltd. (Formerly known as South China Morning Post Ltd.)**

**Star Television Business Ltd.**
**Star Television Entertainment Ltd.**
**Star Television Holdings**
**Star Television News Ltd.**
**Star Television Oriental Ltd.**
**Star Television Sports Ltd.**
**Star Television (India) Ltd.**
**Star Television Production Ltd.**
**Star TV (Taiwan) Ltd.**
**Zoo TV Ltd.**
**THE NEWS INVESTMENTS (AUSTRALIA) PTY. LTD.**
**NEWSCORP INVESTMENTS LTD.**
Newscorp Company (liq. Jan 1994)
**News Finance Pty. Ltd.**
**News International pty.**
Admacroft Ltd.
Broadsystem Ltd.
Broadsystem Properties Ltd. (liq. Jan 1994)
Broadsystem Publication Ltd. (liq Jan 1994)
Canterpath Ltd.
Canterpath Investments Ltd.
City Magazines Ltd. (liq Jan 1994)
Communications and Media Ltd.
Convoys Ltd.
Convoys Pension Trustees Ltd.
Convoys (London Wharves) Ltd.
Convoys Transport Ltd.
Delphi Internet Ltd.
Eric Bemrose Ltd.
Eric Bemrose (engineers) Ltd.
Eric Bemrose Publications Ltd. (liq Jan 1994)
Festival Records International Ltd.
Long Lane Engineering Co. International Ltd.(liq 1/94)
Lyntress Ltd.
Media Debt Collections Ltd.
Murdoch Magazine (UK) Ltd.
Newscorp Finance Ltd.
Newscorp Finance NV
Newscorp Netherlands Antilles NV
Newscorp Services BV (sold 1993)
Newscorp Preference Ltd.
News Collins Holdings Ltd.

**The London And Counties Publicity Co. Ltd.**
**The Sunday Times Ltd.**
**The Sun Ltd.**
**The Times Communications Co. Ltd.** (liq 1/94)
**The Times Data Co. Ltd.** (liq Jan 1994)
**The Times design and Graphics Co. Ltd.** (liq Jan 1994)
**The Times Educational Supplement Ltd.**
**The Times Higher Education Supplement Ltd.**
**The Times Ltd.**
**The Times Literary Supplement Ltd.**
**The Times Network Systems Ltd.**
**The Times Paper Company Ltd.** (liq 1/94)
**The Times Pension Trusts Ltd.**
**The Times Printing Company Ltd.** (liq 1/94.
**The Times Publishing Company Ltd.**
**The Times Supplements Ltd.**
**Times Newspapers Holdings Ltd.**
**Times Newspapers Ltd.**
**Times Newspapers of Great Britain Inc.**
**Times Newspapers Production Company Ltd.**
**TNL Pension Trustees Ltd.**
**Tower Trustees Ltd.**
**Virginia Two Ltd.**
**Virginia Three Ltd.**
**Wardley Chemicals Ltd.** (liq 1/94)
**Welling Storage Ltd.**
**Whitefriars Insurance Services Ltd.** (liq 1/94)
**News Publishers Ltd.**
News Collins L.c.c.
News Collins Nominee Ltd.
News Communication Hong Kong
News Gem Smart Card International Ltd.
News Publishers' Finance BV
News Publishers Netherlands Antilles NV
Newscorp Pub lishers Netherlands BV
Sky Channel B.V
Sky Radio BV

**HARPER AND COLLINS US. INC.**
**Harper Collins Publ. Inc.**
Collins Publ. Inc
Harper Collins Japan Inc.
Editora Harper & Row de Brazil Ltd
Harper Collins Educational Publ. Inc.
Scott, Foresman Leasing Co.
Harper & Brothers. Inc.
Harper & Row U.K., Inc.
Salem House .Ltd. Inc.
The Zondervan Corporation
NAPI G.P. Corporation, Inc
News Investments, Inc.
Bencap Inc.
Bensac Inc.

(East Africa) Ltd
Twentieth Century Fox Film (East) Ltd
Twentieth Century Fox Film (Malaya) Sendirian Berhad
Twentieth Century Fox Film (S.A.) (Pty.) Ltd (liq)
Fox International Equity, Inc.
Twentieth Century Fox France Inc.
Twentieth Century Fox Hong Kong Inc.
Twentieth Century Fox Import Corporation
Twentieth Century Fox Inc.
Twentieth Century Fox India Inc.
Twentieth Century Fox Inter-America Inc.
Twentieth Century Fox International TV L.L.C.
Twentieth Century Fox TC Fox Inter. Telecommunications Dist. Inc.
Twentieth Century Fox Inter. Theatrical Distribution, Inc.
Twentieth Century Fox Italy S.p.A. Inc
Twentieth Century Fox Korea, Inc.
Twentieth Century Fox Latin America Telecom, Inc. (Caymen)
Twentieth Century Fox Latin America TV, Inc. (Caymen)
Twentieth Century Fox Latin America Theatrical, Inc. (Caymen)
Twentieth Century Fox Licensing and Merchandising Corp. (liq)
Twentieth Century Fox Marineland Incorporated (liq)
Twentieth Century Fox Merchandising Ltd.
Twentieth Century Fox Pakistan (liq.)
Twentieth Century Fox Peruana S.A.
Twentieth Century Fox Philippines Inc.
Twentieth Century Fox Productions Inc.
Twentieth Century Fox Puerto Rico Inc.
Twentieth Century Fox Services Inc. (liq)
Twentieth Century Fox Studio Club
Twentieth Century Fox Telecommunications Inc.
Twentieth Century Fox Korea Inc.
Twentieth Century Fox Telecommunications (Germany) Inc.
Twentieth Century Fox Telecommunications (UK) Ltd
Twentieth Century Fox TV Ltd
Twentieth Century Fox Thailand Inc.
Twentieth Century Fox Theatre Productions Inc. (liq)
Twentieth Century Fox Trinidad Ltd.
Twentieth Century Fox (Far East) Inc.
Twenty First Century Fox Corp.
Twenty First Century Fox Varieties Inc.
U.K. Film Distributors Ltd. (liq)
Wedron Silica Co
West End Productions, Inc.
Westgate Productions, Inc.
Wylde Films & Associates Inc (liq)
X+F Productions, Inc.
Zambia Film Services Ltd. (liq)

William Collins Ltd. (dereg. 1993)
Thorsons Publi. Ltd.
Turnstone Press Ltd (dereg. 1993)
Thorsons Retail Ltd. (dereg 1993)
The Alternative Bookclub Ltd. (dereg 1993)
Laser Cassettes Ltd. (dereg. 1993)
Aquarian Press Ltd
William Kimber & Co Ltd.
William Collins (Gill) Ltd.
William Collins (Gi) Ltd. (dereg. 1993)
Harper & Row Ltd.
Unwin Hyman Ltd.
George Allen & Unwin (Publ.) Ltd.
George Allen & Unwin (storage) Ltd.
Bell & Hyman Ltd.
University Tutorial Press Ltd
MSD Holdings Ltd
Multiple Sound Distributors Ltd. (dereg. 1993)
Video Merchandisers Ltd. (dereg 1993)
Warwick Distribution Ltd. (dereg 1993)
Warwick Leisure Ltd.
MSD Trading Ltd.
Tempo Communications Ltd (dereg 1993)
MSD Distribution Ltd (dereg. 1993)
MSD Manufacturing Ltd. (dereg. 1993)
MSD Video Ltd. (dereg. 1993)
Stanley Botes Booksellers Ltd
Dolphin Bookclub Ltd.
William Collins Ltd.
William Collins Ltd. (dereg. 1993)
John Bartholomew & Son (Group) Ltd.
John Bartholomew & Son Ltd.
Harper Collins Pension Trustees Co. Ltd. (formerly HCP(T&TC)Ltd.)
Geographia Ltd.
Times Book Group Ltd
Times Books Ltd.
Invincible Press Ltd.
Robert Nicholson Publ. Ltd
Angus & Robertson Ltd.
Trader Publ. Ltd (dereg. 1993)

**NEWS PUBLISHING AUSTRALIA LTD.**

**News America Holdings Inc.**
19th Holdings Corporation
Austair, Inc.
Comsell Inc. (sold)
Dailhold, Inc.
Delphi Internet Services Corporation
DLO Corporation
Etak Inc.
Fox Broadcasting Co.
Fox Inc.
Fox News Production Inc.
Fox Television Stations Inc.
Fox West Pictures
Houston Community Newspapers Inc. (sold)
Murdoch Publ. Marketing Corporation
Murdoch Magazine Inc.
NAHI Real Estate Corp., Inc.
NAPI G.P. Corporation, Inc.
New Investments, Inc.
New West (sold)
New York Magazine Co., Inc. (liq)
News Air, Inc.

Fox Film De Cuba S.A.
Fox Film de la Argentina S.A.
Fox Film Do Brasil S.A.
Fox Film Music Corp.
Fox Home Video, Inc.
Fox Interamericana S.A.
Fox International Equity, Inc.
Fox International, Inc.
Fox Kids Music, Inc.
Fox LAPTV Holdings Corporation I
Fox LAPTV Holdings Corp. II
Fox Latin American Channel, Inc.
Fox Latin America Basic Cable, Inc. (Caymen)
Fox Latin America, Inc.
Fox Motion Picture Venture No. 1, Inc.
Fox Movietonews Inc.
Fox Net. Inc. (formerly Twentieth Century Fox (Bangkok)
Fox News Productions, Inc.
Fox News Service, Inc.
Fox Overseas Inc. (liq)
Fox Pay-Per-View services, Inc.
Fox Pro Football, Inc.
Fox Records, Inc.
Fox Services, Inc. (formerly Twentieth Century Fox of Indonesia Inc.)
Fox Square Productions (Canada), Inc.
Fox Square Productions, Inc.
Fox Transactional TV, Inc.
Fox UK TV Investment Co. Ltd (sold 1992)
Fox Video Benelux (formerly Fox Video BV)
Fox Video Games Inc.
Fox Video Games International Inc.(liq)
Fox Video Inc.
Fox Video International Corporation
Foxfilmes Limitada
Fox-Monsignore, Inc. (liq)
FoxStar Productions,
FoxVideo Asia Pacific L.L.C.
FoxVideo Canada Ltd.
FoxVideo Club of America Ltd
FoxVideo Club of Europe Ltd.
FoxVideo Espanna S.A.
FoxVideo France S.A.
FoxVideo International SARL
FoxVideo Italia S.p.A
FoxVideo Japan K.K.
FoxVideo Korea Inc.
FoxVideo Latin America, Inc. (Caymen Islands)
FoxVideo Inc.
FoxVideo New Zealand Ltd
FoxVideo South Pacific Pty. Ltd
FoxVideo (Holdings) Ltd.
FoxView, Inc.
Fox/Col Film Distributors, Inc.
FSO Productions, Inc.
FTS Atlanta, Inc.
FTS Boston, Inc.
FTS Investments, Inc
FTS Philadelphia, Inc.
FWA Productions, Inc.
F.N.M. Songs Inc.
Galaxy Way Productions, Inc.
Galileo Productions, Inc.
Games Management Services (liq)
GATV Productions, Inc. (formerly 20th Century Fox Dominican Republic)
Greenleaves Productions, Inc.
Harmon Cove Productions, Inc.

This consolidated list of group accounts is drawn from the 1994 *Financial Report* of The News Corporation Limited. It does not include many of the publications and broadcast stations owned by the Australian-based entity. Parent holding companies are represented in bold caps; the parent corporations are in regular bold above their respective subsidiaries. The newspapers are produced by publishers operating within the various accounts highlighted in red.

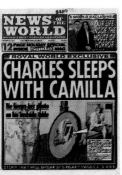

## Brand News & the Product Life Cycle ·

Sensationalism is an assembly-line activity practiced by global corporations to manage their properties in the most cost-effective manner. Optimizing the value of a standardized product may require a customized approach to marketing. In the case of Time-Warner this is achieved by circulating a story through its wholly owned and shared properties, such as The Cable News Network, Headline News, Court TV, HBO, Entertainment Television, and *Time* and *People* magazines. Time-Warner's financial stake in Court TV is a capital investment in sensationalism guaranteed to produce long drawn out criminal trials. Circulating a news story through the branded subdivisons of a parent corporation breeds a familiarity with an event that generates further interest. The sensationalism is a strategy by the information based company to create product based goods for their subsidiaries. For example, *Time* featured an article on sex in America while Time-Warner's subsidiary, Little, Brown & Company, published the study.

This process is analogous to "high-speed management" in the industrial sector where an analyst would study a potential market, model its contents, and then proceed "to simulate its production; calibrate its cost, price, profit and sales potential, [and then] develop

Time-Warner owns *Time* and *People* magazines. The electronic noise on both issues suggests the images were retrieved from a shared, electronic archive. In the assembly-line sensationalism above, the similarity of the photographs highlights the stylistic differences in the logotypes.

The network trademarks are the only distinguishing features on the images below. The saturation coverage of this trial is due in part to Time-Warner's minority interest in Headline News, CNN, Court TV, Entertainment Television,.and The Warner Television Network.

an artificial intelligence system to control its rate."[7] The joint interest of The News Corporation and Time-Warner in the Mighty Morphin Power Ranger toy illustrates the relationship between image management and "invisible endorsement." The toy is owned by the Sega Corporation, a sub-division of Time-Warner, and The Turner Broadcasting System (TBS) of which Time-Warner has a minority stake. The Power Ranger television program airs on The Fox Children's Network and is advertised through *TV Guide* and *The News of the World*, all subdivisions of The News Corporation Limited. On the opening day of the new Congress, mascots representing the Power Rangers appeared greeting the new Speaker of the House who was, at that time, being criticized for a book deal with Harper Collins, yet another division of The News Corporation. Tracing the marketing history of this product through advertising and the news is one of the few methods available for outlining the fused identity and activity of these two corporations.

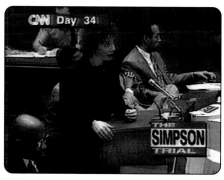

The chart at right is a sample section
of a trademark diagram for Time-Warner Inc.
A complete chart of all the identity
designs would serve as a monolithic form of
identity for the viewing public to reference.
The first vertical row of logos (right)
features primary properties owned
by the company. The other rows include
properties in which the corporation
has less than a fifty-percent interest.
The information is based on the 1993
Annual Report of Time-Warner Inc.

**The Trademark Diagram** · The simultaneous proliferation and fragmentation of identity programs suggests a need for a visual system of checks and balances to increase corporate accountability and, perhaps, the quality for the individual viewing real-time transmission of news and events. The current revolution in the technology of design production has temporarily outpaced the image recognition hardware necessary to study it. Technology currently under development at the Massachusetts Institute of Technology's Media Lab suggests that such a visual accountability is becoming more viable. Identifying the critical financial associations between companies is cumbersome without a visual structure to illuminate the complexity of ownership. Auditing variation in ownership through a visual indexing of logos would make global properties more visible and would create a monolithic identity for the company. A visual summary of media holdings provided in both print and electronic newspapers and magazines would offer the public a simple but comprehensive map of visual transactions in the news. It would also illustrate levels of ownership, enabling viewers to interpret a ticker tape of logotypes with the same efficiency financial analysts track the stock market. This type of trademark diagramming would track the flow of brands through the marketplace. As virtual corporations continue to develop edgeless associations and imagery, the value of information design increases exponentially. Design managers, individual viewers and journalists should decide whether to impose clear borders on increasingly amorphous corporations or leave the public wondering where the imagery of a corporation ends and where it begins.

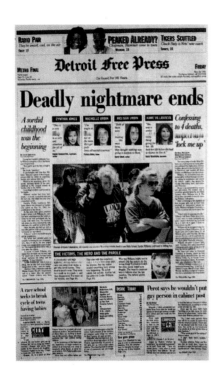

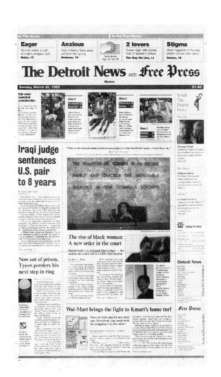

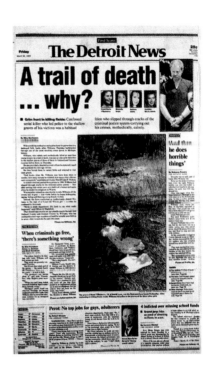

**Design Chains and Newspaper Layout**

The similarity and dissimilarity in the layout designs of newspaper chains cannot quite replicate the monolithic identity of a single corporation. Instead, newspaper chains operate on a continuum of endorsed and branded styles of identification. The "high modern" layout design of Knight Ridder's *The San Jose Mercury News*, *The Philadelphia Inquirer*, and *The Miami Herald* exemplify a clear unity in style.

The style and identity of a newspaper chain may contract in the weekend editions of some U.S newspapers, but the merger between The Sunday edition of the *Detroit News-Free Press (above)* illustrates a merger or reciprocal endorsement between two newspaper chains: The Gannett Corporation's *Detroit News* and Knight Ridder's *The Detroit Free Press*. The more "expressionist" style of layout in *The Detroit News* is displaced in this Sunday edition by the "high modern" layout of *The Detroit Free Press*.

**USA Today The Trademark Front Page**

The editorial guidelines (opposite page) are part of The Gannett Corporation's version of an identity manual for its newspapers. The fever chart (right) is one of many prototypes circulated to Gannett's chain of over eighty newspapers.

The lay-out design of *USA Today* serves as a model for the more regional and suburban newspapers in the Gannett chain. The style associated with Gannett papers has been exported through the international distribution of *USA Today* and appropriated by international publications such as *The European*.

## Effective Packaging

Keep it simple: The simpler something is, the easier it is to understand. Don't overwhelm the reader.

Dare to be Stupid: Readers won't understand if the news staff doesn't understand.

Make it interesting: If the news isn't presented in an interesting way, readers can't be expected to care.

Swing for the fences: Newspapers can only succeed in a big way. Go for it.

Edit with your heart and head: Readers don't want an encyclopedia. They want a newspaper that's comfortable and friendly.

## Layering the News

Headline: Set in stone, introduces coverage

Photo: Documents, evokes emotion

Narrative Summary graphs

Key Facts; roadmap to more coverage

How it happened Window

Supplements story; directs to inside

Infograpic

Design guidelines issued by The Gannett Corporation 1991.

---

**1** Clone the fever line and create a closed-bottom box anchored at the zero point of your grid. Fill the shape and send to back of grid. Date labels can be edited and coded for 9 point Helvetica bold.

**2** Contour feverline should be coded as a 4-point line with rounded ends. Rounded ends can be created by selecting the line, going to Attributes in the menu and choosing fill and line. Select the center choice under Cap and click OK. Pointer boxes should also be added at this point.

**3** The headline, chatter, subheadline, and other text can be added and aligned. Color can be formatted for the background and inside the fever ploygon if desired.

48

**The Tribune Company**

On June 10th, 1947 *The Chicago Daily Tribune* celebrated its centennial anniversary with this family tree of its early history. The company's electronic operations feature news stories from a publisher that once shared a printing press with an abolitionist newspaper and now syndicates the daytime talk show "Geraldo." The electronic menu of today is a branded record of publishing ventures.

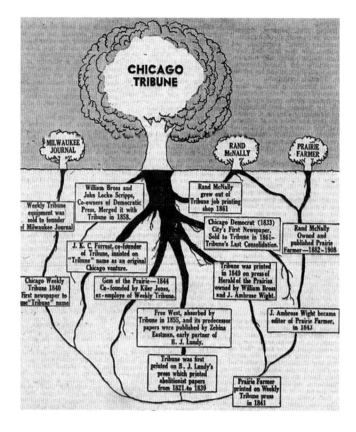

The sample trademark diagram below features logos from subsidiaries of the Tribune Company. The Knight Ridder / Tribune Information Services (TMS, below) is a jointly owned operation that customizes graphics for the daily news.

| Radio | Television | Newsprint | Multimedia |

# BUY TIME

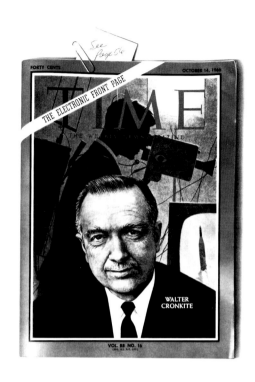

**Capital Connection**   **New York Times**   **ABC News**   **Time Magazine**

### Reciprocal Endorsement

Cultivating the image of a television news anchorman is a form of brand equity. This advertisement, designed by Lou Dorfsman for CBS News, appeared in *Variety* magazine in 1975. Both the copy and the design represent the reciprocal endorsements of two independently owned companies with well-established monolithic identities. This illustration of Walter Cronkite, who had become a national icon, reflects CBS's attempt to associate the image of its anchor with its logo, using Cronkite as a corporate "trademark."

### Protecting Brand Equity

The US & World Electronic menu (left) illustrates a contemporary example of reciprocal endorsement. The visual clustering of these independently recognized icons of mass communication attempt to protect their brand equity by associating with one another and thereby separating themselves from newly formed and aggressive media corporations, such as The News Corporation's Fox Broadcasting Company.

# Was She Right to Go Public?

**After long insisting on anonymity, Willie Smith's accuser raises issues of fairness by revealing herself on TV**

By RICHARD ZOGLIN

**Not a blob: Bowman on *PrimeTime Live***

**A Metagraphic in the News**

The series of images on this spread illustrate the migratory patterns of an electronic corporate graphic as it is transmitted by the mainstream press and then appropriated by social activists. During the William Kennedy Smith rape trial in December of 1991, a circular graphic appeared over the alleged victim's face as a blue dot or a gray smudge. Instead of the digitized blur commonly used in broadcasting today to protect an individual's identity, the blue dot disembodied the witness. The corporate graphic became part of the logo design for the Women's Action Coalition.

1 Bagdakian, Ben, *The Media Monopoly* (Boston: Beacon Press, 1992), p.22.

2 "Trademark 101: The Basics," *Editor and Publisher*, 4 December 1991, p.24.

3 "A Trademark is neither a patent nor a copyright" The United States Trademark Association, p.1.

4 Olins, Wally. *Corporate Identity: Making Business Strategy Visible Through Design,* Cambridge: Harvard Business School Press, 1989. p.87.

5 Olins, p.108.

6 "Just In Case You Hadn't Heard - The 60's Are Over," *Time* (January 30, 1994), p.23.

7 Cushman, Donald Peter and Sarah Sanderson King. *High-Speed Management and Organizational Communication in the 1990's: A Reader.* (Albany: State University of New York Press, 1994), p.132.

including the Nancy, which monitors rnational communi

entire $30 billion-a-bureaucracy of a s is expected to dee same rate as the which is being cut by e 1990 fiscal year to r. It was unclear if budget reductions dy projected.

American intelli

*ge B16, Column 3*

Iranian-backed groups in Lebanon — even during the ill-fated deals to exchange arms for hostages — United States policy was to keep Iran at arms length, resolved that there could be no fundamental change in Washington's attitude until the last American went free.

It now seems evident that the freeing of all the American hostages in Lebanon and the reported deal to let the remaining two Germans go free soon came at the initiative of Iran, which in recent months has repeatedly stated its desire to broaden its economic and political contacts with the West.

Whatever his ultimate plans for dealing with Iran, President Bush reacted cautiously today. He praised the United Nations, Syria, Iran and Lebanon for their help in freeing the hostages, but noted that the story was not over. Two German hostages are still being held in Lebanon, Arabs and Palestinians are being held by Israel, and information about hostages and prisoners who may have died in captivity has yet to be supplied.

When asked about a possible resumption in relations between the United States and Iran, Marlin Fitzwater,

This ambivalence was ev cent American dealings with weeks ago, the United State $278 million for undelivere owned, American-made arm been prevented from being Iran after the fall of the Sh But also, in recent months, States has blocked the sale made planes built with Ame ponents to Iran and urged build a nuclear plant for Ira

Iran was allowed to s amounts of its oil to Americ nies, but only to help fund escrow account at The Hag pay American claims stem Iran's seizure of the United bassy in Teheran in 1979. A European governments hav to sign large projects with Ir tion that Iranian officials a American spoiling.

The assassination of a fo an Prime Minister, Shahpu in Paris this year, the slayi Iranian opposition figures world, and the death ord author Salman Rushdie, w ran has refused to lift after t Ayatollah Ruhollah Khome tribute to keeping Iran on

Continued on Page A21, C

# r in Smith Trial Tells of Fear and Rape

MARGOLICK
ew York Times

ACH, Fla., Dec. 4 — rs, the 30-year-old o has accused Wilping her on the front dy compound took day and offered her ions of that night.

m first as "Mr. simply as "that what she described ution in the defendegan, she said, as a ting person in an aki pants that she tspot Au Bar a few ecame a fiend who ground, forced himantly told her afterver accused him of ever believe her. he raped her, and en the two encounthe Kennedy home, going to kill me."

**on the Stand**

rnoon, Mr. Smith's er, Roy E. Black of ross-examination of to continue Thurs

ad adjourned, Mr. uself to reporters. some very sad and c testimony today," been living with with this damnable months, and I hope patient, as I have e the opportunity, efend myself in the

nained composed, much of her testie begar recounting oved his clothes for g her into running begin to break. For ct examination she iffled and paused down at the floor eep breaths before ter her, she said,

The face of William K. Smith's accuser was obscured as her testimony was broadcast on live television yesterday. The courtroom drama is proving to be a television spectacular. Critic's Notebook, page A24.

# INSIDE

## False Start for Mideast Talks

Syrian, Lebanese, Jordanian and Palestinian negotiators gathered in Washington for peace talks but quickly departed after the Israelis failed to turn up. Page A11.

## A Grim Economic Report

The economy grew at an annual rate of 1.7 percent in the third quarter, considerably less than first estimated and a disappointment to analysts and the White House. Page D1.

## Scholarship Limits Proposed

Education Secretary Lamar Alexander announced a proposal to ban scholarships based exclusively on the recipient's race except in some circumstances. Page A26.

## Pan Am Is Shut Down

Out of cash and unable to attract more, the airline closed its doors, laying off thousands. Page D1.

## Maxwell Troubles Mount

The Maxwell publishing family was said to be preparing to put its private companies into bankruptcy. Page D1.

# Bonilla Br
# But Old

By

When Bobby Bonilla sig million dollar contract with this week and became th paid athlete in professio sports, the South Bronx n quick to say he wanted to g his old neighborhood and s something back.

The one place in the Bron not be getting anything bacl soon is Mr. Bonilla's aln Herbert H. Lehman High S

Mr. Bonilla, who graduat has refused to have anyth with his old school since its forced the resignation of la's beloved baseball coa years ago.

**Lehman Had High Ho**

The feud between Lehma celebrated alumnus and Leder, its feisty principal s has distressed school offic had hoped that the newly famous baseball star wou some of his luster — and c ings — its way. Mr. Leder, i lavished Mr. Bonilla with in letters offering to name th weight room "The Bobby Weight Room" and plea scholarship donations and h pation in special events. N

# A Baby and a Coathanger :
## TV News
## and Other Graphics on Abortion

MAUD LAVIN

A fetus floating in amniotic fluid. Tiny fetal feet dangled by a pair of adult hands. A mutilated, bloodied aborted fetus with a misshapen head and a missing arm. A doctor gagged. A coat hanger, dripping red. A dead woman, naked, her body partially covered by a sheet. Since 1973 when the Supreme Court issued the *Roe v. Wade* decision making first-trimester abortion legal in the United States, the abortion debate has become increasingly visual. Using new technologies in fetal imagery like ultrasound sonograms, the right-to-life movement expanded its propaganda, emphasizing design and photographs. The pro-choice movement produced generally less dramatic and less effective images of pregnant women, happy planned families—and that icon of desperation, the coat hanger.

Most often, the visualization of the abortion debate has made the polarized arguments narrower. The imagery—and often the graphics as well—have tended to focus the discussion on individual rights of either the fetus or the mother while prompting almost no consideration of pertinent social contexts. Pictures of aborted fetuses and the like do not often lead to discussions of issues such as the contemporary economics of raising a child or the mechanics of adoption. Omitted in the abortion debate's picture-heavy propaganda are thorough explorations of a range of problems from the domestic—responsibilities for child raising within the family—to the national—lack of social services for families in the U.S.—to the global—perspectives on birth control and the population.

The focus on individual rights, of course, cannot be solely ascribed to the increased use of images; in our highly individualistic culture, propaganda usually emphasizes personal choice whether it's choice between brands of shampoo, types of cars, or the slants of political candidates. However, the visual repetition of portraits of fetuses and mothers has worked to pin the abortion debate's issues tightly to individual rights. Furthermore, the reduction of the abortion debate to a choice between the mother's rights and a fetus's has far-reaching consequences that are actually harmful to women. The abortion controversy is probably the single most comprehensive public, visible, and noisy debate on women's issues in the nation. Yet ironically, the current status of the discourse—the telescoping-down to a war of a few images, mainly the pro-life helpless fetus versus the pro-choice helpless women—effectively blocks full discussion of societal issues on women and children that require democratic debate and legislative action.

In order to create a broader public discourse, it's helpful to consider first how the narrowing has occurred and to look at how images have functioned on both sides of the abortion debate to further exclude context, and then to follow with a discussion of some possibilities for using design, photography, and other images more ambitiously to increase the social effectiveness of current debates.

The author of Cut with the Kitchen Knife (Yale UP), a monograph on the Berlin Dada artist Hannah Höch, Maud Lavin has written on culture and politics for The New York Times Book Review, The Nation, Art in America, Harper's Bazaar, I.D. Magazine, Ms.; the anthologies Montage and Modern Life (MIT), Graphic Design in America (Abrams), Global Television (MIT); and other publications.

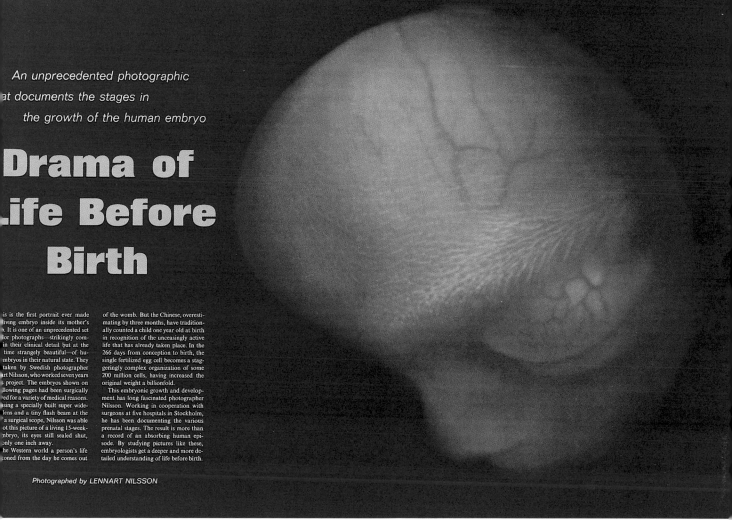

*An unprecedented photographic ... at documents the stages in the growth of the human embryo*

# Drama of Life Before Birth

...is is the first portrait ever made ... living embryo inside its mother's ... . It is one of an unprecedented set ... or photographs—strikingly com- ... in their clinical detail but at the ... time strangely beautiful—of hu- ... mbryos in their natural state. They ... taken by Swedish photographer ... rt Nilsson, who worked seven years ... s project. The embryos shown on ... llowing pages had been surgically ... ed for a variety of medical reasons. ... using a specially built super wide- ... lens and a tiny flash beam at the ... a surgical scope, Nilsson was able ... ot this picture of a living 15-week- ... nbryo, its eyes still sealed shut, ... only one inch away.
... he Western world a person's life ... oned from the day he comes out

of the womb. But the Chinese, overesti- mating by three months, have tradition- ally counted a child one year old at birth in recognition of the unceasingly active life that has already taken place. In the 266 days from conception to birth, the single fertilized egg cell becomes a stag- geringly complex organization of some 200 million cells, having increased the original weight a billionfold.

This embryonic growth and develop- ment has long fascinated photographer Nilsson. Working in cooperation with surgeons at five hospitals in Stockholm, he has been documenting the various prenatal stages. The result is more than a record of an absorbing human epi- sode. By studying pictures like these, embryologists get a deeper and more de- tailed understanding of life before birth.

*Photographed by LENNART NILSSON*

## Prehistory of the Image Wars

In the decades leading up to the 1973 decision, media coverage of abortion was limited but tended to contain at least some contextual issues. Illegal abortion was widespread and opinion was divided about when it was appropriate or not; in some cases and in some localities abortion was even legal. Before *Roe v. Wade,* a patchwork of local and state laws and regulations were in place. For example, in some states, a hospital committee could approve an abortion if the mother's life was in danger. Cultural historian Celeste Condit reports that by 1971 as many as 600,000 legal abortions were performed in the U.S. each year as well as countless illegal ones.[1]

The fifties and sixties saw an increased media coverage about the practice, particularly newspaper and magazine profiles of women having illegal abortions. In the press, discussion was not so much about the moral choices associated with abortion as it was about the fate of the women involved. These articles tended to portray women as powerless victims, either mistreated by

[1] Celeste Condit, *Decoding Abortion Rhetoric: Communicating Social Change* (Urbana: U. of Illinois Press, 1990): 22.

back alley abortionists or subject to invasive scrutiny by hospital boards and doctors. As Condit has argued, "for a broad public to feel sorry for the agent and angry with the forces that bring her suffering, the character depicted must be 'good' or, at the least, unable to control her own destiny."[2]

[2] Celeste Condit, *Decoding Abortion Rhetoric: Communicati* *Social Change* (Urbana: U. of Illinois Press, 1990): 25.

Rise of Fetal Imagery

In 1965 there was an important shift in the types of images available to the abortion debate. *Life* magazine published the startling, entrancing, full-color images of the fetus at different growth stages by Swedish photographer Lennart Nilsson. Most of the photographs

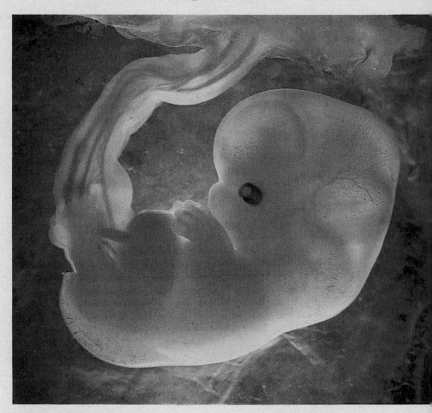

## The Change—Embryo to Fetu

### 6 ½ WEEKS

Rising from the dark, bulbous liver and curving up to the placenta at top of picture is the umbilical cord. Its two arteries and single vein, filled with blood, are plainly visible. Through the placenta the vein brings in food, oxygen and various chemical substances from the mother, while the arteries take back waste material for the mother to get rid of. Though the embryo now weighs only 1/30 of an ounce, it has all the internal organs of the adult in various stages of development. It already has a little mouth with lips, an early tongue and buds for 20 milk teeth. Its sex and reproductive organs have begun to sprout. With all its major bodily systems laid down, the embryo is now becoming much less susceptible to serious damage from outside sources.

### 8 WEEKS

This is the transition point where an embryo, a Greek word meaning to swell, starts being called technically a fetus, a Latin word meaning young one. The key to this switchover is the formation of the first real bone cells that begin to replace the cartilage. This is seen in the close-up of the feet at right. At far right, in a close-up about 40 times actual size, the eye is still open, but gluey ridges are beginning to form at their edges which will soon seal the eyes shut to protect them in their final delicate formation. They will not open again until the seventh month. The nostrils, seen only as dim shadows, are also plugged up with protective material at this stage.

were taken of embryos and fetuses that had been surgically removed from the mother. However, the introductory image in the photo essay was, "the first portrait ever made of a living embryo inside it's mother's womb.... [U]sing a specially built super wide-angle lens and a tiny flash beam at the end of a surgical scope, Nilsson was able to shoot this picture of the living 15-week-old embryo, it's eyes still sealed shut, from only one inch away."[3] To this day, the details of the photographs fascinate us with their intimacy: the framing of the red crystalline encasing of an eleven-week fetus and the view of a twenty-eight week old fetus veiled in it's membrane. The spectacle is heightened by showing all the fetuses outside of or separate from the mother

[3] "Drama of Life Before Birth," photographed by Lennart Nilsson, *Life*, 30 April 1965.

(the womb is invisible in the living embryo portrait). This visually dramatic technique was later often reused with an ideological slant in right-to-life propaganda. As cultural historian Rosalind Petchesky and others have argued, when viewers become familiar with seeing the fetus independent of the mother, they can more easily begin to consider fetal rights as if separable from maternal ones. [4]

Ultrasound images of fetuses also became available in the sixties and seventies and commonplace in the seventies—in everyday use and in propaganda. First introduced into obstetrical practice in the early 1960's, the procedure, used on pregnant women, is to create either a still image (scan) or a real-time moving image by bouncing sound waves off the fetus in the womb. By the mid-eighties, over one-third of all pregnant women in the U.S. were examined with ultrasound. To date the most well known pro-life incorporation of ultrasound moving imagery is in *The Silent Scream,* the 1984 film showing a fetus in real time undergoing an abortion.

With the use of ultrasound images in abortion propaganda, as with close-up fetal photographs, anti-abortion activists developed their primary propaganda technique where the fetus is shown without reference to the mother's body and the mother is depersonalized. She is not portrayed as a real person with a life history and an economic context. This technique has now become highly sophisticated. For example, in a current National Right-To-Life Committee brochure, in an image reminiscent to one of Nilsson's photographs, a color photo of an enlarged fetus surrounded by placenta is shown on a black background. The accompanying text, addressing the reader as "you" uncannily appeals to the reader to identify directly with the fetus while bypassing any consideration of the mother. The brochure takes us step by step through the growth process and reads at month three, "your movements became more energetic, less mechanical and more graceful and fluid, very much like an astronaut floating and enjoying his gravity-free space capsule. Your arms grew to be as long as printed exclamation marks and your fingers and toes quickly formed, complete with fingerprints which gave you a separate legal identity that would never change except for size."

This compelling propagandistic use of the fetus raises questions about why readers might identify so strongly with the image. To look at photographs of fetuses is to be stunned by the spectacle of human life unfolding and to be captivated, with pictures of more developed fetuses, by their baby-like qualities. However, beyond this, the connotations of innocence and helplessness are used in pro-life literature in a particular American way. The individual as the protagonist of persuasive literature is a typical American device. Also, images of children, especially fetuses, present an "innocent" individual, whose origins are guilt- and blame- free, and who is deserving of care and help. The importance of individual identity for our culture could relate directly to our deep identification with fetal imagery. The unmoored fetus,

[4] Rosalind Petchesky, "Fetal Images: The power of Visual Culture in the Politics of Reproduction," *Feminist Studies* (Summer 1987): 263-92.

then, functions as a symbol of innocence, of the frontier, and of the open road of choice—of birth and rebirth, of an individual beholden to no one, especially to his or her mother, and yet, deserving of protection from everyone.

## TV News Graphics

TV graphics, to take one example from the array of images under discussion, have done little to expand the already narrow visual debate on abortion. The caution in these designs is perpetuated by the generally homogenous style of design in broadcast news. Graphic designers for television also leave out social context. In general, with such controversial topics, TV graphic designers tend to create bland, inoffensive images to frame behind the newscaster to introduce stories or to insert within news coverage to clarify charts, maps, and quotes: the Supreme Court building and the American flag; the Supreme Court building and the Capitol building; the word ABORTION repeated four times; the word ABORTION alone in dull, thick sans-serif type. But because of the sheer numbers of viewers reached, TV graphics, however subtle, do have influence in the public discourse on abortion.

It's even possible to read meaning in what TV designers leave out: they hardly ever use fetal imagery. Steering clear of these visuals means avoiding the pro-life connotations they often carry. With the flood of fetal imagery produced by pro-life groups, at this point, almost any image of a fetus has come to symbolize an argument for fetal personhood. This is particularly true of any image of a well developed fetus; one of the most egregious use of images by the anti-abortion movement has been to portray a second or third trimester fetus and misstate or imply that it is a first trimester or early second trimester fetus.

In a mid-eighties survey of people who worked in TV and print media, a full 90 percent of those polled said they believed a "woman has the right to decide on abortion." Not surprisingly, pro-life groups have persistently complained about a pro-choice slant in the media such as a lack of investigative reporting about "the abortion industry" and a misrepresentation of the moderate, mainstream character of the largest right-to-life organizations by spotlighting instead the violent, clinic-bombing fringe groups. Nevertheless, in the case of TV news graphics, a careful neutrality has been courted, although, almost by default, a slight pro-choice slant can be traced. The cautious note sounded by the introductory graphics—as in the clichéd image of the Supreme Court building juxtaposed with the American flag hung to the right of the announcer's head—contrasts all too sharply with more imaginative protest signs ("With Clinton you get Gore") waved in demonstrations covered in the news story itself. Even acknowledging that the designer's job is to match the desired objectivity of the TV reporter and not take sides, the graphic content still seems narrow.

Robert Lichter, Stanley Rothman, Linda S. Lichter, *The Media Elite* (Bethesda, MD: Adler & Adler, 1986): 29.

Marvin Olasky, *The Press and Abortion, 1838-1988* (Hillsdale, N.J.: Lawrence Erlbaum Associates, 1990).

Although restricted about content, TV designers regularly create visual drama, as in the April 26, 1989 CBS broadcast on how the court was expected to vote in a possible overturn of *Roe v. Wade*. As a voice-over explained how the Justices were likely to vote, photographs of each one peeled off like playing cards from a deck to form two rows: pro-choice Brennan, Marshall, Blackman, and Stevens against pro-life Rehnquist, White, Scalia, and Kennedy. The finale: The last rectangle, portraying O'Connor, filled the center of the grid—the possible swing vote.

Into the eighties the most common intro graphic on TV was simply the word ABORTION reflected along a diagonal—yellow on a red and orange ground (CBS 1982) or set on a diagonal again, orange letters on a red banner (CBS 1983). On January 18, 1985 a daring NBC designer changed that. The broadcast, "Abortion Issue Flares Up as 12th Anniversary of Supreme Court Ruling Legalizing Abortion Nears," presented a comic-book graphic behind Peter Jennings' head announcing, "TARGET ABORTION" over an abstract explosion of white and red rays with each letter in orange above fading to yellow below. Within the story a timeline chart showed the increases in clinic bombings from 1977 to 1985, accompanied by a signature, postmodern graphic in the upper left of a broken green column with the letters of ABORTION stumbling unevenly across the jagged edges.

Still, the usually stolid TV graphics have effectively illustrated to the TV audience the chipping away of the abortion right in the U.S. by illustrating the cumulative, national picture of state restrictions on abortion. One may argue that TV graphics serve pro-choice interests by sounding a warning to the majority-pro-choice TV audience about the increasing difficulty of obtaining an abortion in the U.S. For example, when the former President Reagan proposed the gag rule forbidding doctors at federally funded clinics from discussing abortion with their patients, the July 30, 1987 CBS story showed images of a clinic with sound-bites worth of words. These may have flowed too quickly past the viewer if not for the chart illustrating that 4.3 million a year used government-supported family clinics and of these 3.7 million were poor. Simply and provocatively plotted with cubic columns representing the numbers and with outlines of women humanizing the column, the graphics demonstrated the huge number of lives to be affected by Reagan's proposal.

The charge of a slight TV media bias toward the pro-choice movement may be sustained when examining the coverage of anti-abortion actions across the country. Here again, more-or-less neutral graphics have been used to underline the effects of attacks on abortion clinics and of pro-life resistance to pro-choice legislation. The point remains, however, that both TV coverage in general and TV news graphics in particular leave out contexts of the economics of child raising and other urgently relevant social issues. The importance of what is left invisible outweighs the extremely subtle political biases of the visuals.

Altogether, there is a visual abortion-debate forum at present in which most TV graphics range from the bland to the serviceable; the polemical print graphics of the National Right-to-Life Committee are harder hitting but focus primarily on issues of individual choices, and Planned Parenthood's print propaganda usually centers on individual women and families. There are some instructive exceptions however in the PP literature that addresses social context. Is it possible to imagine or find examples of visual propaganda that links personal decisions to societal context and group political action? Why is there a near-total silence on alternatives to abortion such as birth control and adoption and on the social issues surrounding the pressures of raising children nationally and globally?

Planned Parenthood has given some of these questions thought and even pictures. For example, their literature and their programs have consistently promoted the use of birth control and expanded birth control research. A well argued piece of propaganda (a glossy one-page handout produced during the Bush years) is punctuated on the top and bottom with white-on-black call-outs: NOTES FOR A NEW ADMINISTRATION / A KINDER, GENTLER NATION BEGINS WITH FAMILY PLANNING. Presented in a tabloid-like layout, the text announcing "federal funding for contraceptive R&D has declined 25%—in real dollars— over the past decade" is headlined "If you have a complaint about your birth control, here's where to send it" and illustrated by a photograph of the White House. Still, none of PP's images to date have the comprehensive ad-campaign-star charisma of the fetus featured in the pro-life imagery. A call for government-funded preventative social services is crucial, but it doesn't quite have the drama of life-and-death abortion choices.

Complex issues, even the urgent ones, can be difficult to translate into images. Particularly slippery is the whole issue of victimhood when it's a status claimed for the mother. As Condit has noted, the spotlight is on the innocent victim in the abortion debates. But if the "victim" is portrayed as too pathetic, identification breaks down—if represented as too strong and independent then, in our hyper-individualistic culture, she is seen as undeserving of help. Images of grown women are tricky in this regard. One Planned Parenthood hand-out negotiates stereotypes of independence and victimhood with a two-thirds page melodramatic photograph (caption superimposed "How would you like the police to investigate your miscarriage?") of a white middle-class woman opening the door of her home to two plainclothes policemen. She is the victim of an invasion of privacy: An analogy is established between police intruding in her home and the government potentially threatening her freedom of choice. The picture of this invasive fantasy, though, has none of the impact or biological realism of images of a growing fetus.

In the same newspaper-format series of one-page hand-outs is "Poverty doesn't come cheap." It illustrates a photo of a healthy but ragged child leaning out of a glassless window from inside a ghastly apartment. The text makes a multi-layered plea for sympathy for children who are victims of poverty and for empathy with parents trapped in poverty by unintended pregnancy—and also of taxpayers' self-interest by demonstrating how much unplanned pregnancies cost. But the healthy little boy in the photo looks like he's doing alright despite all odds. Planned Parenthood has avoided producing yet another overly pathetic image of a poor person (the common, dehumanizing stereotype), but offers instead a boy who looks surprisingly untouched by circumstances.

Yet within the individualistic culture we've inherited, what alternatives to mainstream abortion graphics could be effective? The challenge is to connect portrayals of individuals (the mother, the fetus) to broader contexts, ones that move the discussion toward social change in conjunction with individual choice and responsibility. Images and propaganda can prompt fuller fantasies of a dual identification, with both an individual and a community, and also a creative sense of the interconnectedness between people. In some cases, such propaganda already exists, in others it is to be imagined.

First, as positive examples, some activist artists and designers have produced work that lobbies for abortion rights and also raises issues about women's self-images. Some artists have raised identity issues in graphics primarily created in response to immediate political situations—Barbara Kruger with her pro-choice imagery, Bethany Johns and Georgie Stout for WAC (Women's Action Coalition), and Marlene McCarty and Donald Moffett with their design students at Yale. Kruger's pro-choice poster "Your body is a battleground" designed for a march on Washington (1989) presents a photograph of a woman divided into positive and negative halves. Characteristic of Kruger, the photomontage points to the use of women's images in the pull of mass culture's seductions; Johns and Stout's poster, also created for a pro-choice march on Washington (1992), uses the printed image of Durer's praying hands with the caption "Pray for Choice" to recapture the claim of morality for the pro-choice movement; McCarty and Moffett's students dealt with the issue of shame by painting a billboard (1992, the spring before the Clinton-Bush presidential election) outside New Haven with black letters over a yellow ground stating "73% of America is pro-choice: Why doesn't it seem that way?" The next year, in 1993, McCarty and Moffett's students formed the Coalition to Free RU486 and created a media kit for television talk shows which was distributed to Oprah, Donahue, and ten others. It contained the usual press gimmicks like a T-shirt stating "I want my RU486," but also information on legalization, biographies of potential talk show guests on both sides of the issues, and factual information about the drug's use in abortion and other medical procedures. Significantly, these designers were not restricted to formal concerns, but rather took responsibility for content and research and strove to manipulate the media, not just produce for it.

Conclusion

Today we have an abortion debate that's stuck. Dominated by fetal imagery, it talks about sanctity of life and personal choice without any broad discussion of our societal conditions of life and hard pressing factors that make up the choice of whether or not to bear a child. Although pro-life literature, more than pro-choice, veers away from any questions of government intervention, both sides downplay societal-wide responsibilities for raising the next generation. We need to expand the debate to get to the real issues that define how people make their difficult public and private choices and to examine how to consider these choices, as solely individual or as perhaps community based.

So, how can we change the debate and democratically open it up to issues that desperately need widespread discussion? Can we imagine visual propaganda about reproductive rights that also proselytizes for a more generous vision of citizenship and mutual responsibility? Concretely, in my view, these are the issues we need to discuss and to create visual propaganda about: family allowances, adoption policies, health care reform for families of all classes, high quality subsidized child care, equal pay for women, enforcement of child care payments. These are key reproductive rights issues that inform whether or not to carry a pregnancy to term. On the most basic level, we need to acknowledge the relationship between giving birth and raising a child—and government and community, as well as individual and familial responsibility for the next generation of citizens—a goal we need not be distracted from by magnified photos of the free-floating spaceman fetus and images created in reaction to him.

Ironically, or perhaps not, one of the few community oriented pieces of propaganda existing now is a 1994 TV ad funded by the right-wing De Moss Foundation in the series "Life—What a Beautiful Choice" produced in conjunction with the National Right-to-Life Committee. It shows a rainbow group of inner city children in school uniforms sitting on school steps. While the voice-over preaches against abortion, the visual image is one of equal opportunity and an implication of quality services well-provided. It gives a societal vision of fairness for the next generation that is unfortunately far from the truth—and that gap is what begs for more discussion in the abortion debate.

*This version of the essay is part of a longer piece to appear in* Clean, New World,

*an anthology of writings on graphic design and politics by Maud Lavin to be published*

*by Farrar, Straus & Giroux.*

© *Maud Lavin, 1995*

Thanks to
Ken Francis,
Tamar Jacoby,
Kim Larsen,
Ellen Lupton,
Eris Messinger, and
Lawrence Mirsky for
their contributions
to this essay.